P9-EMO-713

"I am progressing very slowly, for nature reveals herself to me in very complex forms, and the progress needed is incessant."

"Painting ... means perceiving harmony between
numerous relationships and transposing them according
to a new, original logic."

"For if the strong feeling for nature—which I assuredly have—is the necessary basis for all conception of art on which rests the grandeur and beauty of all future work,

"Modeling is the outcome of the exact relationship of tones. When they are harmoniously juxtaposed and complete, the picture develops modeling of its own accord."

CONTENTS

CÉZANNE
FATHER OF 20TH-CENTURY ART

Michel Hoog

DISCOVERIES
HARRY N. ABRAMS, INC., PUBLISHERS

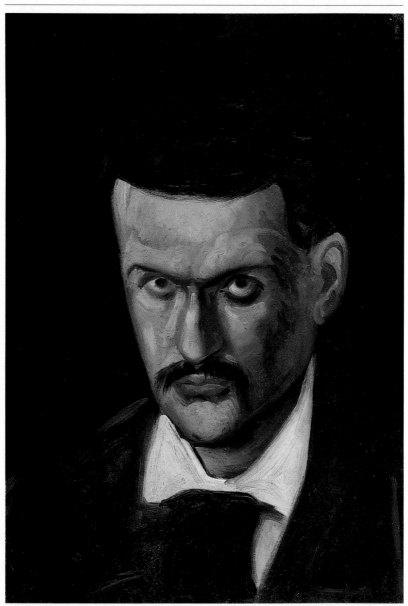

"The banker Cézanne does not see without fear
Behind his desk a painter appear."

It was with these words that a brilliant schoolboy
from a sleepy town in southern France stated his
determination to become a painter—in spite of
the wishes of his businessman father.

CHAPTER I
YOUTH

Working from a photograph (a novelty in the early 1860s), Cézanne deliberately made himself look very unattractive in this self-portrait of 1861–2 (opposite). His sallow complexion, his staring eyes, and his frown make him look almost diabolical. Later self-portraits, which never portrayed him smiling, lack the dramatic quality of this painting.

Cézanne Spent His Childhood and Youth Quietly and Studiously in Aix-en-Provence

Paul Cézanne was born on 19 January 1839. He had two sisters, Marie and Rose. His father, Louis-Auguste, had made enough money in the hat trade to found the only bank in Aix-en-Provence in 1848. He exerted his parental authority to the full when Paul chose to become an artist, but he does not seem to have been unduly severe with his children. Cézanne's mother, Anne-Elisabeth (née Aubert), an intelligent and lively woman about whom little is known, appears to have encouraged the artist and to have supported him when there were arguments between father and son.

Young Paul learned to read at the local primary school, then spent two years at the Ecole Saint-Joseph. In 1852 he entered the first form of the Collège Bourbon at Aix as a boarder. He received his baccalaureate—with a "quite good" grade—in 1858. Cézanne left the school with an excellent knowledge of Latin, Greek, and ancient and French literature. He was able to compose poetry in Latin and French with great ease and several of his poems or fragments of plays, generally bombastic and sometimes a little racy, survive.

All his life Cézanne remained true to his humanist education. The man who rejected every tradition in painting had classical tastes in literature, read widely, and kept up with literary trends.

In 1852 Paul Cézanne Came to the Aid of Emile Zola

Emile Zola (1840–1902) was also a student at the Collège Bourbon. He was sickly, fatherless, severely shortsighted, and often bullied by his fellow students until Cézanne, who was bigger and stronger, began to stand up for him. The day after Cézanne first intervened, Zola brought

This portrait of Marie Cézanne (c. 1866, below left), sister of the artist, is one of the very few portraits of women from Cézanne's early years. It was treated in a thick impasto applied with a palette knife. Cézanne liked this quick and somewhat crude technique. It went against accepted academic tradition and strongly contrasted with the smooth and over-polished painting taught at Aix.

There are some ten portraits of Dominique Aubert (above, one painted in 1866), the brother of Cézanne's mother. He was a docile and obliging model for his nephew.

some apples as a present for his protector. A bond was forged between these two children that would last until 1886. Both boys were to become famous.

There was a third boy at the Collège Bourbon, Baptistin Baille (1841–1918), a future engineer, and he, Cézanne, and Zola made an inseparable trio. They spent their days off going for walks in the countryside around Aix and, in the summer months, swimming in the Arc River. In a letter dated 5 February 1861, written to Cézanne from Paris, Zola recalled these outings with nostalgia. "Alas, no, I no longer wander the countryside, I no longer lose my way among the rocks of Le Tholonet and above all I no longer make my way with a bottle in my game-bag to Baille's little estate, that unforgettable shooting box [hunting lodge] reminiscent of wine."

A good pupil who had won many academic prizes, Cézanne never complained about his school years, during which he gained a solid classical education. Above: The Collège Bourbon (later the Lycée Mignet). In the photograph at left, Saint-Jean-de-Malte's belfry marks the site of the Municipal School of Drawing, built onto the side of the church. The countryside surrounding Aix was the scene of many of the young Cézanne's outings and later served as the subject of his paintings.

A City-dweller in Love with the Open Air and Music

Cézanne preferred the most secluded parts of the countryside around Aix. When asked his favorite smell in the Cézanne family game "Confidences," he replied "the smell of the fields," and his favorite leisure activity, "swimming." In a letter to Zola of 9 April 1858 Cézanne wrote, "Do you remember the pine that grew on the side of the Arc [River] and leant its bushy head out over the chasm yawning at its feet? This pine that protected our bodies from the burning sun with its needles, ah! may

the gods preserve it from the deadly blows of the woodcutter's ax!"

Cézanne showed a fondness for his birthplace and a love of nature—plants, the woods, and swimming in that river—that was uncommon in his generation. He differed here from most of his future fellow Impressionists, who remained city-dwellers and for whom nature was identified solely with the public gardens in Paris and with the orchards of the Ile-de-France.

Cézanne and his friends also amused

themselves by playing music. In the "Jolly Fellows" band founded by young Emile Zola, the future painter performed on the cornet, while Zola played the clarinet. When Cézanne went to live in Paris, he took his instrument with him. Zola soon lost his enthusiasm for music but Cézanne—like his contemporaries Edouard Manet, Pierre-Auguste Renoir, Henri Fantin-Latour, and Paul Gauguin—was devoted to it. Cézanne confessed to

"No, I make off
Over the changing waves
As happily as in years
 gone by,

When our agile arms
Like serpents swam
Over the gentle waves.

Goodbye, happy days
Seasoned with wine!
Lucky catches of
 huge fish!"

Cézanne
letter to Emile Zola
9 April 1858

an admiration for Richard Wagner (1813–83) at a time when the controversial German composer was unpopular in France. At the end of his life Cézanne even stopped going to vespers ostensibly because the assistant priest in the cathedral played the organ so badly.

The son of an Italian immigrant, Louis-Auguste Cézanne (below) founded a bank in Aix in 1848 that brought him considerable wealth.

Following His Father's Wishes, Cézanne Enrolled at the University of Aix to Study Law. But He Was Drawn in Another Direction

Louis-Auguste Cézanne was a self-taught man, and with hard work and intelligence he had become very well-off. He hoped that his son, after further studies, would embark on a brilliant legal career and become a lawyer or a judge. What a step up it would be for Louis-Auguste, who was scorned by the aristocracy of Aix—because he was not a native, because he had married one of his employees, and because two of the couple's children (Paul and Marie) had been born before the marriage—to see his son presiding over the court of appeals in Aix-en-Provence!

The young Paul Cézanne seemed to accept the idea, initially at any rate, of following this classic 19th-century route to social advancement. But neither banking nor law interested him, and little by little he turned toward that most discredited of all professions in the bourgeois mind, that of the artist.

"I shall get an idea of the risks that painting runs when I see your attempts," said Cézanne's art teacher Joseph Gibert (below) on seeing his former pupil's canvases at the first Impressionist exhibition in 1874.

In 1857, Before Finishing his Secondary Education, Cézanne Enrolled in the Aix Free Municipal School for Drawing

Cézanne's art teacher at the Municipal School was Professor Joseph Gibert, who, following a practice common in the 19th century, was not only director of the drawing academy but curator of the local museum, the Musée Granet, as well. His teaching, supplementing the instruction of the Collège drawing courses, did not show great originality. Gibert passed on to Cézanne a certain facility in using then-popular methods, including the copying of plaster casts of ancient sculptures and the study of live models. The painter would always maintain good relations with

Gibert and would show deference to him, even though Gibert's authoritarian ways and out-of-date art might have justified a certain hostility on his part. More than likely this attitude can be explained by the respect that Cézanne always showed toward those in some form of authority, or by the fact that he simply was grateful to Gibert for having taught him the rudiments of art.

During 1859 and 1860 Cézanne was simultaneously keeping up both his law studies and a professional painting course at the Municipal School. In 1859 he won second prize for a figure painting, and his father allowed him to continue as a painter.

The First Known Work of the Young Cézanne Is His Decoration of the Jas de Bouffan, a Property Acquired by His Father in 1859

In purchasing this large 18th-century house in a beautiful park a little over a mile from the center of Aix, Louis-Auguste Cézanne was trying to gain social acceptance by having both a winter and a summer residence, as was the custom among all the "better" families of Aix. The young Paul loved this house, and he stayed and worked there frequently. The imposing building and the trees in the park can be seen in many of his paintings and watercolors.

The painting of a mural on a wall of the drawing room at the Jas de Bouffan was undertaken with his father's consent soon after the house was purchased. The mural consisted of an allegory of the four seasons, to which Cézanne later added other subjects, including a portrait of his father. *The Four Seasons* panels no doubt helped Louis-Auguste decide to let his son "go up to Paris," a step which had first been authorized in 1860, then quickly rescinded, and at last agreed on in 1861.

The panels of *The Four Seasons* (originally painted for the Jas de Bouffan, below, and now at the Musée du Petit Palais in Paris) show female figures in the style of hand-painted wallpapers or romantic screens. *Autumn* (opposite left) and *Spring* (opposite right) feature elegant, graceful silhouettes and recall the figures of Italian painter Sandro Botticelli (1445–1510) in their poses. These beginner's paintings are not without ambition. The incisive drawing, the clarity of the contours, and the elongated arms all explain why Cézanne ironically signed the picture "Ingres." Neoclassicist painter Jean-Auguste-Dominique Ingres (1780–1867) was then the obligatory reference point of all academic teaching.

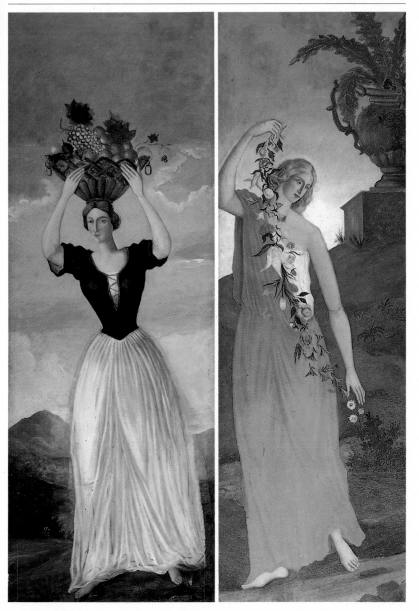

To Live in Paris: The Dream of Every Ambitious Young Person in the 19th Century

The centralization of administrative power and the concentration of all the big schools and cultural institutions in Paris explain this longing. To these must be added the freedom from the strict morality of provincial life, reputedly to be found in Paris. This applied particularly to the world to which young Cézanne dreamed of belonging, namely, that of the arts. The provincial schools—with the exception of the one in Lyons—were extremely undistinguished, if not moribund, and all the great artistic battles took place in Paris. The Salons (the annual official art exhibitions) and the controversies they aroused every year, the great state commissions, Gustave Courbet's special exhibition of 1855, of all these only distant echoes reached the provinces. It was in Paris, and in Paris alone, that a young artist could train and make his mark. Was not Paris the capital of the arts? Did it not attract artists from all over the world?

This sketch of people gathered around a table is the precursor of *The Cardplayers.* It was included in a letter to Emile Zola (above right) written on 17 January 1859, and entitled "Death reigns in this place."

"I Would Want…to Risk All to Gain All, and Not Hesitate any Longer Between Two Such Different Choices for My Future, Between Art and the Law"

Needless to say, Cézanne, who felt strongly that art was his vocation, also dreamed of going to Paris. Added to his ambitions as a painter was an intense longing to free himself from his family and its constraints.

Zola, who had been in Paris since 1858, wrote to him regularly and encouraged him to follow his true calling. In a letter of July 1860 Zola writes, "Is painting only a whim that came up and seized you one fine day when you were bored? Is it only a pastime, a subject of conversation, a pretext for not working at the law? If it is like this, then I understand why you are behaving

in this way: You do well not to push things to extremes and not to make new family troubles for yourself. But if painting is your vocation —and I have always thought of it in this way—if you think you are capable of doing well after having worked hard, then you are an enigma to me, a sphinx, an impossible and impenetrable mystery."

Zola came back to Aix in the summer of 1860, and no doubt his urging had something to do with Cézanne's decision to leave Aix for the capital.

Eugène Delacroix, who died in 1863, was a model for many painters of Cézanne's generation. Below: Cézanne's portrait of Delacroix (1864–6).

"I Am Working Calmly, Eating Well, and Sleeping Likewise"

In November 1862, after one false start (an earlier move to the city in April 1861 had ended in discouragement in September of the same year), Cézanne settled in Paris, where he led a simple and studious life. He frequently worked either at the Atelier Suisse (a studio where, for a monthly fee, artists could sketch or paint live models) or at home and often visited museums. He attended the annual Salons with much interest. Starting in 1863 he was a frequent visitor to the Louvre, where he practiced by copying the works of the masters. He also went to the Luxembourg Museum, which was reserved for living artists, and there discovered the works of someone who would become one of the painters he most admired: Eugène Delacroix (1798–1863). *The Massacre at Chios* (1824) and *Dante and Virgil in the Inferno* (1822) were hung side by side with the works of disciples of Ingres.

Cézanne and Zola, toting art supplies and books, continued their boyhood

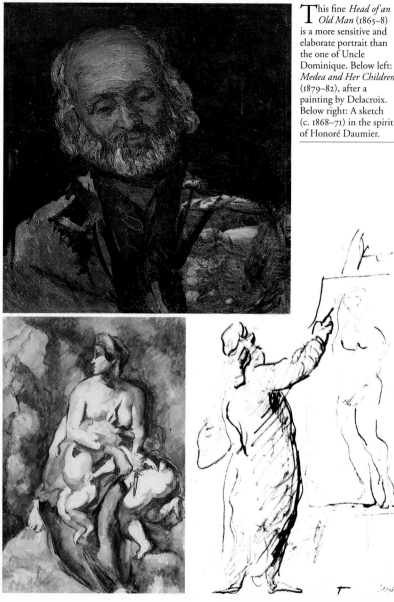

This fine *Head of an Old Man* (1865–8) is a more sensitive and elaborate portrait than the one of Uncle Dominique. Below left: *Medea and Her Children* (1879–82), after a painting by Delacroix. Below right: A sketch (c. 1868–71) in the spirit of Honoré Daumier.

tradition of making excursions to the countryside on their "free" days. Cézanne went to the cafés much less frequently than his fellow artists and preferred the company of his friends from Aix—Zola and the painters Numa Coste and Achille Emperaire, both of whom Cézanne had met at the Municipal School.

Cézanne Was Lucky and Did Not Have to Endure the Extreme Poverty Suffered by Other Artists

Cézanne was able to live on the allowance that his father paid him and that his mother no doubt discreetly supplemented. "My good family, excellent, it must be said, in other respects, is for a poor painter who has never known what to do, perhaps a little miserly. It is a minor fault and doubtless excusable in the provinces," he wrote. He had simple tastes which he never abandoned, even when he inherited his father's fortune. No doubt Louis-Auguste hoped that his son would either become discouraged or else would meet with success by following the more acceptable paths. He encouraged Paul to enroll in the Ecole des Beaux-Arts and to compete for the Prix de Rome, the winners of which were granted a year's study in Rome. But neither of these hopes was realized. The young Cézanne continued his work, but as an independent painter, failing the entrance examination for the Ecole and suffering repeated refusals from the Salon.

When he visited Aix, he was sure of bed and board at the family home. Apart from his need to steep himself in the atmosphere of Aix again, perhaps board and lodging were motives for his frequent return to the region. Cézanne no doubt suffered from being too dependent and from unfavorable criticism of his work, but his attitude to his father continued to combine deference with determination to protect his vocation.

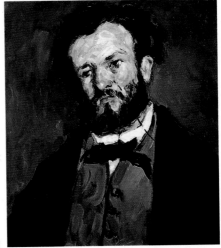

Antony Valabrègue (above), poet and art critic, was a member of the little group of men from Aix who were fond of frequenting Parisian cafés. Cézanne, the surly provincial, felt ill at ease at the Café Guerbois, which had grown to symbolize the artistic life in Paris; he often retreated into silence and reacted violently when he ran into opinions opposed to his own. One evening he even provoked Manet: "I won't shake hands, M. Manet, I haven't washed for a week."

"I Cannot Accept the Unjustified Criticism of Fellow Artists Whom I Have Not Myself Expressly Asked to Appraise Me"

Cézanne came up against the Salon jury for the first time in 1863, when he sent in a painting that was rejected. It was the year when the jury proved so severe that Napoléon III, facing a wave of protest, decided that a Salon des Refusés, an exhibit of the rejected works, would also be held for the public's appraisal. Cézanne found his works there, along with those of his friends Camille Pissarro (1830–1903) and Armand Guillaumin (1841–1927), Henri Fantin-Latour (1836–1904), James Whistler (1834–1903), and especially Edouard Manet (1832–83), who caused a great scandal with his painting *Le Déjeuner sur l'Herbe.*

The experiment of the Salon des Refusés was not repeated in the next few years in spite of a haughty letter written by Cézanne on 19 April 1866 to Count de Nieuwerkerke, the director of fine arts at the Salon, in which he expressed his scorn for the jury and the right of an artist to show his works to the public. "I wish to appeal to the public and show pictures in spite of their being rejected. My desire does not seem to me to be extravagant, and if you were to ask all the painters in my

Painters rejected by the Salon once had no chance of becoming known. In 1863 the "rejected" artists managed to form an exhibit in a side-wing of the exhibition hall. This show was strongly ridiculed, as can be seen in the caricature published in a newspaper of the time (below): "My son! Take off your cap! Honor the courage of these unfortunates!"

Manet's *Le Déjeuner sur l'Herbe* (1863, below left), was based on *Fête Champêtre* (c. 1510) in the Louvre (a painting that was at one time attributed to Giorgione). Manet's study of a nude female in the company of clothed men was judged to be immoral.

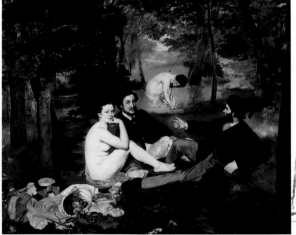

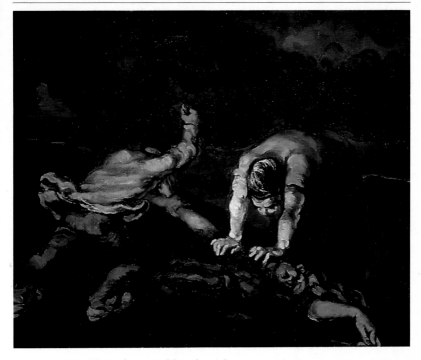

position, they would reply without exception that they disown the jury and that they wish to take part in one way or another in an exhibition that should be open as a matter of course to every serious worker."

The Young Painter Tried His Hand at All Styles, and His Output Before 1870 Is Quite Difficult to Classify

Cézanne himself destroyed many of his paintings. Very few of those that remain are dated, and the countless historians who have studied them disagree about the chronology and the interpretation of the scenes represented.

The style is not consistent. Some successes bear witness to a thoroughly mastered craft,

Cézanne successfully fused technique and subject matter. In violent scenes (above, *The Murder* of around 1867–8) and in the slightly caricatured early portraits, he worked very quickly. The thick brushstrokes are clearly visible, and there is frequent use of the palette knife. His much more peaceful still lifes are worked with a smoother and more thoughtful brush.

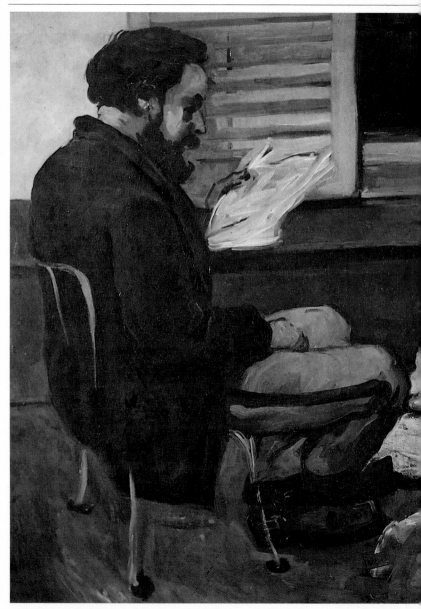

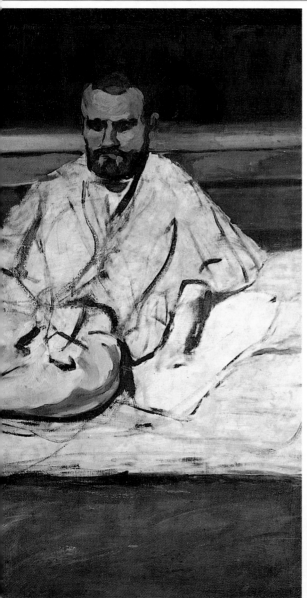

Paul Alexis Reading to Zola

Paul Alexis (1847–1901), who also came from Aix-en-Provence, was Zola's disciple and for a little while his secretary. Cézanne here has given him the part of the reader. The painting (1869–70) was left unfinished, a very rare occurrence for Cézanne, who preferred to destroy works with which he was not satisfied. Zola's figure, barely sketched in, creates a striking contrast to the rest of the canvas. The portrait of Alexis, seated and in profile, recalls Manet's famous picture of Zola (below), which was painted only a year or two earlier, in 1868. Cézanne's painting was discovered in Zola's attic many years after his death.

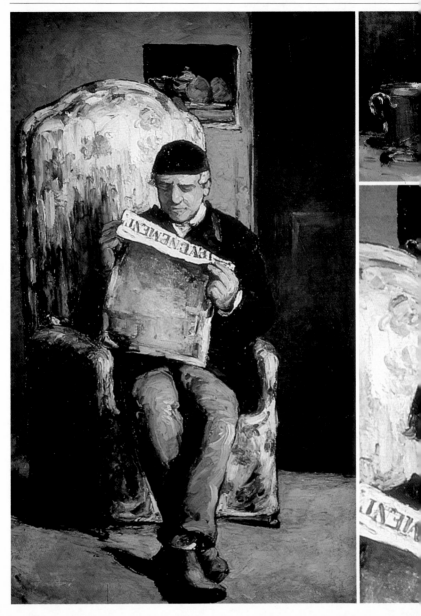

while others give the impression of clumsiness. This is caused variously by faulty technique, haste of execution, or deliberate caricature. It is known that Cézanne complained about his lack of ability and difficulty in realizing his visions on canvas.

Quite early on in his career, the painter's themes were already diverse. Even before 1870, Cézanne was rendering still lifes made up of familiar objects, portraits (almost exclusively masculine), landscapes, allegorical figures, and—contrasting strongly with these traditional themes—some violent and gruesome scenes, such as *The Autopsy, The Rape, The Orgy, Afternoon in Naples,* and *The Temptation of Saint Anthony.* He tried out every style, whereas most painters favored only one or two.

The Painter Twice Painted His Father Reading the Newspaper

Did Louis-Auguste Cézanne really pose, or did his son take the opportunity to paint him while he was sitting still? The older of the two portraits was given a place of honor in the Cézannes' drawing room in the Jas de Bouffan, between the allegories of *Summer* and *Winter.*

Three or four years later the other portrait of his father showed the mastery acquired by Cézanne in Paris. This time the masses are cleverly disposed in space. Light and shade are handled with care, especially on the face and the

Cézanne was making a point in revealing the name of the paper his father was reading. It was not his father's usual newspaper, but *L'Evénement,* which had in April and May 1866 published some very aggressive reviews of the Salon (it was referred to as a "mass of mediocrity"). Using a pseudonym, Zola wrote reviews that caused a scandal. The editor of the paper suspended publication of the articles and fired Zola. One of the young painter's still lifes is hung behind the armchair—*Still Life with Sugar Bowl, Pears, and Blue Cup* (1863–5, left above). Should we give a symbolic meaning to the fact that Louis-Auguste has turned his back on a work by his son?

armchair (a piece of furniture that appears in several
other paintings). Cézanne's work here is close to Monet's
and Renoir's, in a period that in retrospect may be
thought of as the prelude to Impressionism. Cézanne's
originality lies in his working method—the painting was
largely executed with a palette knife—and in the strength
of contrast between the pure whites and the grays and
blacks. Cézanne also experimented with this tonal
contrast in his still lifes.

The most monumental portrait of this time is, however,
the strange likeness of Achille Emperaire. Emperaire was
a painter from Aix with whom Cézanne had worked at
the Atelier Suisse and to whom he remained very attached.
On the deformed body of a dwarf the man possessed "a

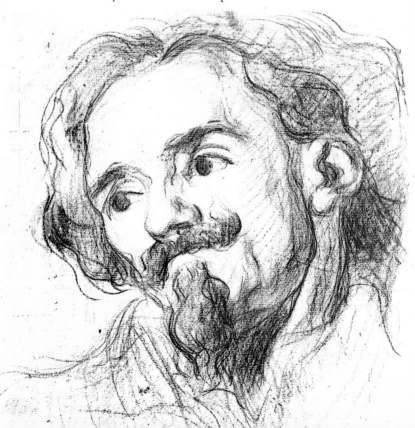

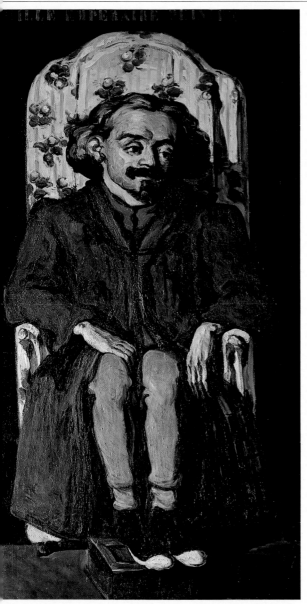

This portrait of Achille Emperaire was bought successively by two painters, Emile Schuffenecker, a friend of Paul Gauguin's, and Eugène-Guillaume Boch, one of Vincent van Gogh's models. Cézanne in his later years wished to destroy it, but it has always claimed attention, even if only for its size and its intrinsic quality of caricature. We know that it was painted a little before 1870, as Cézanne tried to get it admitted to the Salon that year. The painter was then on a search for a style or, as he himself said, for a "formula," a voluntary quest relying more at that moment on the study of the past than on analysis of his sensations. The frontal viewpoint, the gaudy colors, the note of caricature, and the inscription in printed characters were a mixture of the archaic with the sign-painter's craft. The same armchair is to be found again in his father's portrait and, though empty, in *The Overture to Tannhäuser,* painted in about 1866.

Opposite: A sketch of Emperaire.

magnificent head like that of a Van Dyck cavalier."
Curiously, Cézanne executed several preparatory drawings
for this picture that were devoid of any caricature, whereas
the oil painting emphasized the ridiculous and pitiable
side of the individual.

At the same time, he undertook a new and enormous
composition on a wall of the Jas de Bouffan, *Christ in
Limbo with Mary Magdalen.* When removed from the wall
in 1907 the work was cut in half, and the two paintings
have since been treated as distinct; but an old photograph
proves the two halves were originally united. The two
halves—*Christ in Limbo* on the left and *Mary Magdalen*
on the right—fit together poorly, and it is thought that
perhaps the *Mary Magdalen* was to have formed part of an
entombment scene that was never painted.

"No Painting Done Indoors, in the Studio, Will Ever Be as Good as Anything Done in the Open Air"

In a letter to Zola written on 19 October 1866, Cézanne
explained his views on plein-air (outdoor) painting:
"When out-of-door scenes are represented, the contrast
between the figures and the ground is astonishing, and
the landscape is magnificent. I see some superb things
and I shall have to make up my mind only to do things
out-of-doors."

Cézanne's subject
matter, although
mostly drawn from
traditional themes, did
not include any religious
scene other than *Christ
in Limbo with Mary
Magdalen* (below left). It
is believed that the figure
of Christ is copied from a
painting by Sebastiano
del Piombo (c. 1485–1547)
in the Prado Museum,
and *Mary Magdalen* (also
known as *Sorrow,* below
right) recalls a painting
by Domenico Feti
(1589–1623) in the Louvre.

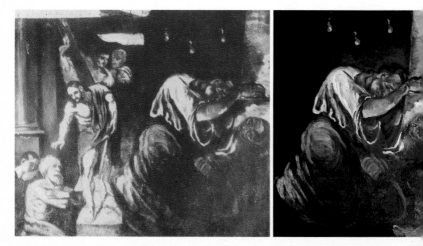

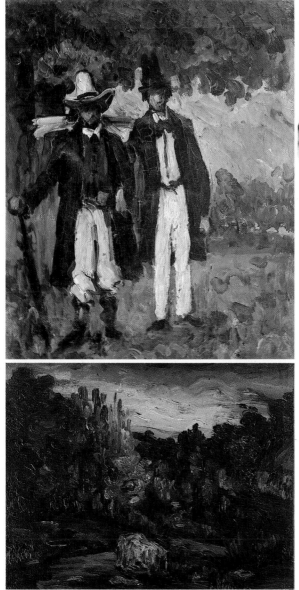

Fortuné Marion (photograph above), a friend from Aix-en-Provence, accompanied Cézanne on excursions into the Parisian countryside. He was a geologist and an amateur painter. *Marion and Valabrègue Setting out to Paint from Nature* (1866, left), in which the two friends are dressed for outdoor painting, was Cézanne's first manifesto for the plein-air school.

It is difficult to see if the heavy forms in this landscape (1865–7) are trees or rocks. The artist portrays a wild and primitive nature with the same energy with which he paints his models' faces.

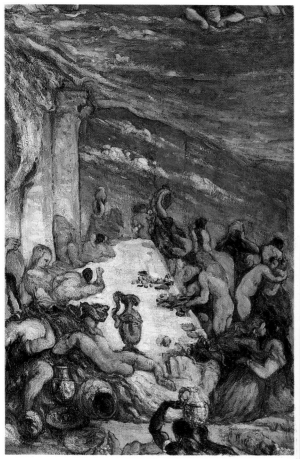

The *Orgy* (c. 1870, left) is a canvas of exceptional size. Cézanne was insistent it should appear in his first one-man show in 1895, just when his art had taken a completely different direction.

The landscapes of this period do not herald Impressionism; rather they are reminiscent of Courbet or the Barbizon School (a group of early 19th-century painters in the vicinity of the village of Barbizon, near Paris, who painted landscapes based on the Northern Baroque, rather than Neoclassical tradition). Using dark colors with deep blacks and greens, Cézanne created relief in a rather academic way, by a succession of parallel planes.

Orgies, Drunken Revels, Abductions—Many of the Early Canvases Reveal a Strongly Sensual Temperament

Little is known, however, of the emotional life of the young Cézanne. His letters contain allusions to student love affairs, which perhaps remained platonic. *The Orgy,* one of the most elaborate canvases of the period, groups people, either naked or in fantasy costumes, around a table which seems to be overturned. The figures are entwined in utter confusion. Cézanne, who had mastered the distribution of mass and space on canvas, deliberately gave this composition an agitated feeling of violence. His range of colors is very bright, indeed shocking for the time. The light greens, reds, and great blue sky contrast sharply with the range of tragic blacks, dark greens, and Prussian blue of the other paintings of this period, as

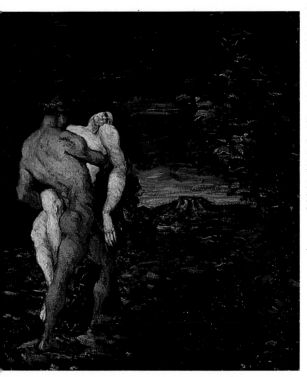

"One of his most remarkable paintings of this period [1866–70] was done at Zola's house in the Rue de la Condamine, and Cézanne made his friend a present of it. This painting, *The Abduction* [*The Rape*], dated 1867, even though not reaching the 12 or 15 feet of which the artist had dreamed, measures 35 by 46 inches. It represents a large green plain done in vivid, comma-like strokes that make it look like troubled water. Against this a nude giant strangely bronzed stands out. In his arms he carries a pale woman with blue-black hair; from her hips falls a dark blue drape. The harmony between her white skin and the bronze of the man, surrounded by the blue material and the green plain, is harsh. In the background, in front of a white cloud, arises a mountain vaguely reminiscent of Sainte-Victoire. At the left two little pink bodies of young girls enliven the composition."

John Rewald
Cézanne: A Biography
1986

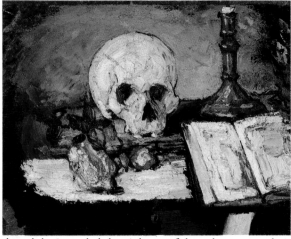

though he intended the violence of the colors to match that of the subject. In the same vein there are several little pictures which, by the standards of Cézanne's time, would have been called pornographic if he had been able to exhibit them. These erotic subjects disappeared around 1870, shortly after he met Hortense Fiquet, his future wife.

Cézanne also Works in What Was Then Considered a Minor Genre: Still Life

A very popular genre in the 18th century, still life was all but neglected by Neoclassical and Romantic painters. It was only toward 1860, doubtless because of renewed interest in the genre painter Jean-Baptiste-Siméon Chardin (1699–1779), whose works had just been shown in a major exhibition, that strong and independent personalities such as Courbet, Manet, and Fantin-Latour found still life a preferred genre for their experiments. Cézanne was similar to Manet in his use of rich blacks, grays, and white, and in the very unorthodox practice of lighting his still lifes from the front.

Some of Cézanne's still lifes—including the one visible in the portrait of his father reading the newspaper—were executed with a palette knife. The crude strokes, the accentuated contrast between light and dark, and the simplicity of the composition connect this group of

Still Life with Skull and Candlestick (1865–7, above left) is typical of early still lifes in that the choice of objects is traditional but the technique and the lighting are determinedly modern.

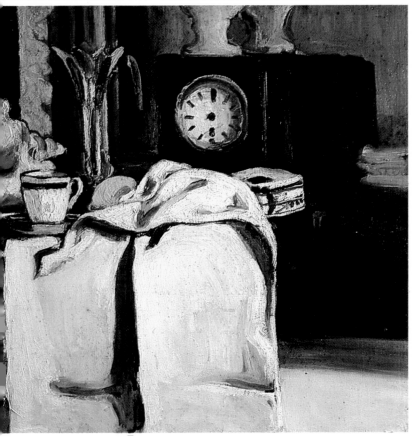

works to a few portraits in which Cézanne can be seen to be openly expressing the violence of his temperament.

Others show a more restrained treatment and a more ambitious construction. However, their precise date is too uncertain to be able to state that these are more mature works. The structure of the composition is sometimes based on a pattern of squares, as in *Still Life with a Black Clock,* where the folds of the tablecloth are depicted with great care.

Cézanne's first still lifes are almost exclusively devoted to fruit. Cézanne gradually introduced other objects

The black clock, painted without hands by Cézanne, belonged to Zola. The tablecloth falls in four rigid folds, recalling the rockface of the quarries in the countryside around Aix.

chosen not only for their simplicity of form or clarity of surface, but also for their significance: a clock without hands, shells, an almost-burned-out candle, and skulls were explicit symbols of the shortness and transience of life. These props recall the paintings of macabre still lifes, called *vanitas*, that were a 17th-century tradition.

Cézanne Showed That He Could Combine His Figures to Create Plastic Form

Cézanne explored a kind of composition that many painters, major and minor alike, have had difficulty in mastering: the scene with two figures. Some, like Renoir, concentrated on expressing feelings of love, friendship, sympathy, or even a simple, fleeting relationship between two people. The efforts of Manet (with a few exceptions), Degas, and Fantin-Latour usually show scenes that evoke feelings of alienation, no matter how crowded the scene.

Cézanne, who was devoted to music, painted three different versions of an interior showing a young girl playing the piano. He painted these canvases—all of which were called *The Overture to Tannhäuser*—in about 1866, long after the performances of Wagner's *Tannhäuser* at the Paris Opera had been deliberately disrupted by a public hostile to the composer's revolutionary style.

The composition of *The Overture to Tannhäuser* (c. 1866, below and detail opposite) is rigidly structured by a series of right angles (the armchair, the uprights of the sofa, the smaller chair, the pianist's arms, and the piano itself). All the elements of the picture are either parallel or perpendicular to the canvas plane. A gentle diffused light, subdued colors, and delicately blended reflections on the armchair give the scene the poetic quality of a Vermeer or a Chardin. Touches of glaze make the whites and grays appear to vibrate.

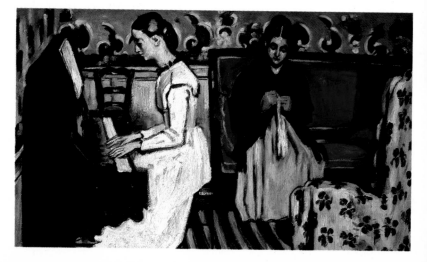

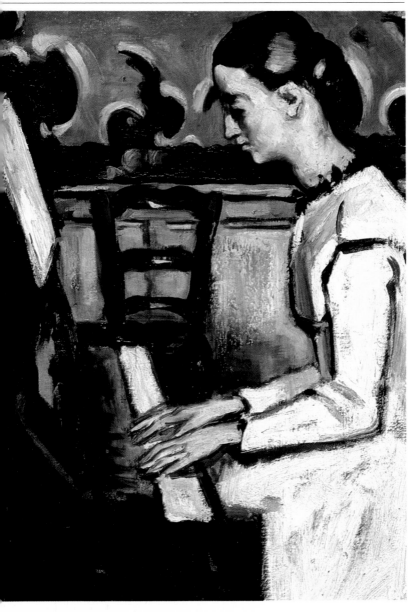

In 1869 Cézanne Met Hortense Fiquet, a Nineteen-year-old Artists' Model in Paris Who Would—Much Later—Become Madame Cézanne

The first paintings in which Fiquet's beautiful oval face can definitely be recognized date from after 1871. She was to become Cézanne's most available and patient model. The painter lived with Hortense Fiquet for years without the knowledge of his family or, at any rate, of his father.

In the spring of 1870, Cézanne's offering was once again rejected by the jury of the Salon. On 31 May he attended Zola's marriage to Gabrielle Meley in Paris, and then he set off for Aix.

When the Franco-Prussian War, which led to the fall of Napoléon III's Second Empire, broke out, Cézanne

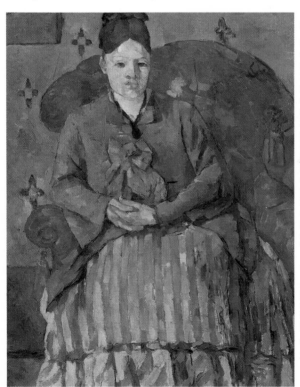

Cézanne is here (above) portrayed by the caricaturist Stock with the two paintings—the portrait of Achille Emperaire and a nude, now lost—that were rejected by the Salon jury of 1870. "Courbet, Manet, Monet, and all of you who paint with a knife, a paintbrush, a brush, or any other instrument, you are all outmoded! May I present your master: M. Cézannes [*sic*]." This caricature appeared in Stock's Paris weekly in the spring of 1870.

Female portraits, rare in Cézanne's early years, became much more numerous after Cézanne met Hortense Fiquet in 1869. Left: *Madame Cézanne in a Red Armchair* (1877).

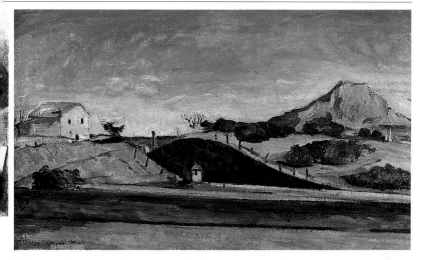

did not rush to join the army. He had no intention of interrupting his work. He instead went to live with Hortense Fiquet in a house which had been rented by his mother at L'Estaque and that was often to serve him as a refuge. The police looked for him in vain at Aix.

The lack of patriotic feeling in Cézanne "the deserter" is difficult to interpret. Totally absorbed in his passion for art, Cézanne was indifferent toward most other people, and during his whole life never showed the slightest interest in civic matters.

About eighteen miles from Aix, L'Estaque was then a simple village on the shore of the Mediterranean. Cézanne often depicted its picturesque features with the hills falling straight into the sea. After a few months "in hiding," the couple returned to Paris.

Unfortunately, not one of the known paintings of L'Estaque can be dated with any certainty to his first stay there. Prolonged observation of the sea certainly contributed to the lightening of Cézanne's palette and to his interest in the study of reflections: He was hardly concerned with any of these matters before this time, but they had for several years preoccupied his companions Pissarro, Monet and Renoir. This change appeared in Cézanne's painting only later, around 1871 or 1872.

This uninviting landscape (1870) of the outskirts of Aix—in which the path cut through the hill for the railway opens up like a wound—is dominated by Mont Sainte-Victoire. This is the first, and for a long time the only, painting Cézanne made of this mountain near Aix which would later be a frequent inspiration.

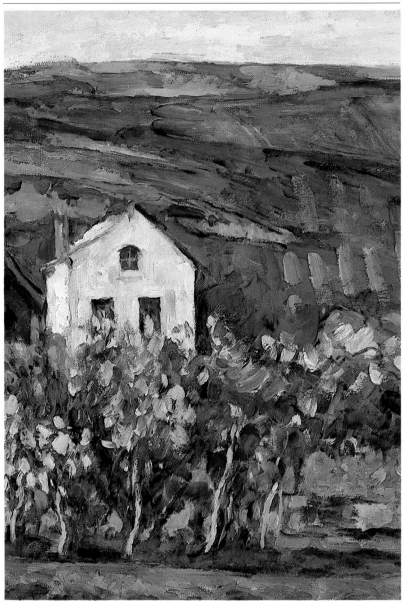

Since a few years before the war, Pissarro had lived in the country at Pontoise, north of Paris, surrounded by young painters. Cézanne joined this group in 1872, accompanied by Hortense Fiquet and their infant son, Paul. Thus commenced some ten years of relative serenity for Cézanne, much needed following the anxiety and soul-searching of his youth.

CHAPTER II
THE IMPRESSIONIST PERIOD

The countryside around Pontoise greatly contributed to Cézanne's artistic development. His range of colors lightened, and the violent contrasts of blacks and whites made way for bright colors. Right and detail opposite: *The Little Houses at Auvers* (c. 1873–4).

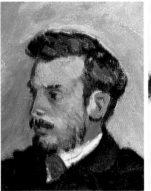

The landscapes being created by Monet, Renoir, Sisley, and their friend Pissarro broke away from the patterns set by previous generations. These painters became more and more interested in the effects of light on nature, the human figure, clouds, and water. They discovered that shadows were not uniformly brown or black and that light could change the color of objects. They abandoned literary, historical, and narrative subjects and instead adopted a modern portfolio of subjects, predominantly outdoor scenes and, in Monet's case, waterscapes.

Such experiments could only be carried out using suitable techniques. So they invented them: color laid on with small hatched brushstrokes, a jumble of different colors on the canvas itself, elimination of browns and blacks, and quick execution out of doors, almost always at the scene being painted. This revolutionary approach earned the small group of artists (who had not yet been called Impressionists) the mockery of both the uncomprehending critics and the public.

Stylistically Cézanne Joins the Group of Innovators Somewhat Belatedly, in 1873

When he came to live in Pontoise in 1872, Cézanne had already known Pissarro for seven or eight years and Armand Guillaumin, another painter in Pissarro's circle, for even longer. He was familiar with the work of his friends, and they with his. Guillaumin went as far as to

The Impressionist movement was not born in a day, the result of improvisation or a chance discovery, as Monet and Renoir later allowed people to believe. For about ten years, Pissarro, Monet, Renoir, Guillaumin, and others had all been working in the same direction. Above from left to right: Renoir (by Frédéric Bazille, 1867), Guillaumin (by Cézanne, 1869–72), Pissarro (photograph), Sisley (by Renoir, 1874), Monet (by Renoir, 1875), and a photograph of Cézanne setting out to paint from nature at Auvers.

declare that Cézanne was a greater painter than Manet. They were all independent thinkers who rejected the heavy, rigid, academic spirit then dominating the Salons. However, for a long time Cézanne took little part in his friends' experiments. His feelings were expressed in dark colors laid on in large swathes—with little importance given to light—and through the use of narrative or allegorical subjects, whereas the others were concentrating on recording only what they observed.

The first paintings to show that Cézanne had adopted the new style of painting were the landscapes and still lifes he did at Auvers-sur-Oise, the town near Pontoise where Cézanne and his family took up residence in early 1873. The gray-greens and browns were still dominant but no longer laid on in great uniform patches, and the compositions were finely structured.

This "conversion" in Cézanne's style has generally been attributed to Pissarro, who was without a

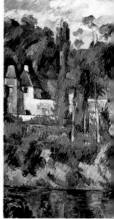

doubt an extremely gifted teacher. He is also credited with later introducing both Gauguin and Van Gogh to Impressionism. But his influence does not explain everything. Why would Cézanne, in the course of a few months, reject one technique to adopt another when examples of it had been known to him for several years? Was it the result of lonely seaside meditation at L'Estaque during the winter of 1870–1? Was it the sudden realization that his own somber style had reached a dead end?

The First Impressionist Exhibition Aroused as Much Hostility as Curiosity

In the 19th century young artists had little opportunity outside the official Salon to show their work and make themselves known. And Cézanne and his friends were almost always rejected by the Salon jury, which was resistant to new ideas.

It was Monet who had the courageous and unusual idea of organizing an independent exhibition in order to give artists the chance to exhibit their work in public without having to adhere to the constraints of the Salon. The exhibition was held from 15 April to 15 May 1874. Some thirty artists of varying stature took part, but those who led the field were the ones history has grouped under the name Impressionists: These were Edgar Degas,

Guillaumin, Monet, Berthe Morisot, Pissarro, Renoir, Alfred Sisley, and, of course, Cézanne.

The critics could not understand them. They were put off by the new techniques—so far removed from the overpolished finish of academic painting—and by the absence of a subject or anecdote on which to pin a commentary. The painters were either attacked for their lack of intellectual honesty or doubt was cast on their mental stability. Monet was given the worst treatment. He exhibited eight works, one of which was a view of Le Havre harbor entitled *Impression, Sunrise* (1872–3). The title was mocked by the critics, and one, Louis Leroy, was responsible for sarcastically inventing the name "Impressionists" for the group. The artists, however, decided to adopt it.

Journalist Marc de Montifaud Did not Spare Cézanne: "A Sort of Idiot Who Paints in the Throes of Delirium Tremens," She Wrote

Cézanne showed three paintings in the 1874 exhibition, two of which have been identified: *The House of the Hanged Man, Auvers-sur-Oise* (1872–3), and *A Modern Olympia* (c. 1873). A study, *Landscape at Auvers,* has not been identified for certain.

The House of the Hanged Man, one of the few paintings by Cézanne to be exhibited several times in his lifetime, has always been considered the most important canvas he painted during his Impressionist

Cézanne, under the tutelage of the "humble and colossal" Pissarro—as he called the generous master who was always ready to give young artists advice— noticeably lightened his palette. Opposite: *The Hermitage at Pontoise* (c. 1867) by Pissarro. Left: Cézanne's *The Château of Médan* (c. 1879–81).

In order to put on the first Impressionist exhibition in 1874 the Société Anonyme des Artistes-Peintres, Sculpteurs, Graveurs, etc., a group of about thirty artists, was formed. Nadar (Félix Tournachon, 1820–1910), a famous photographer, loaned the group his former studio at 35 Boulevard des Capucines (photograph left). Pissarro made sure Cézanne was included in the exhibition in spite of the wishes of those who feared that Cézanne's overprovocative painting would be found too objectionable. Monet also put in a good word for Cézanne.

period. The chosen spot, an ordinary village road, the raw light of the Ile-de-France, the use of light silvery coloring even where there was shadow, and the summary brushstrokes of a brush heavily laden with paint brought this canvas close to contemporary ones by Monet, Pissarro, and Sisley. But what was a search for spontaneity to his friends became for Cézanne a conscious yearning for discipline and a renunciation of his former style.

It is not known whether it was Cézanne's intention to

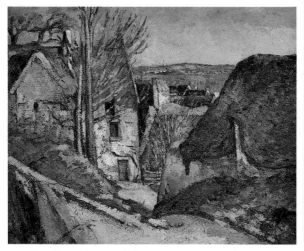

parody Edouard Manet's famous painting, *Olympia* (1863)—which had created such a scandal at the Salon of 1865—or to pay homage to it. A recumbent female nude, lacking a respectable alibi in myth or popular fable—her stark modernity accentuated by the bouquet of flowers and the black servant and cat—appeared to be no more than a prostitute. Cézanne knew Manet and admired him but, since he was in awe of the elegant Parisian, saw little of him. Cézanne painted two versions of *A Modern Olympia*. In the first (c. 1867) he believed himself to be more modern than Manet by enlarging on what Manet had only suggested. The presence of a gloating client who looks like Cézanne, the still life, the large blue-and-gold baroque vase and green plant, the black servant

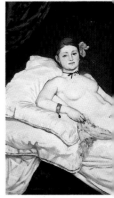

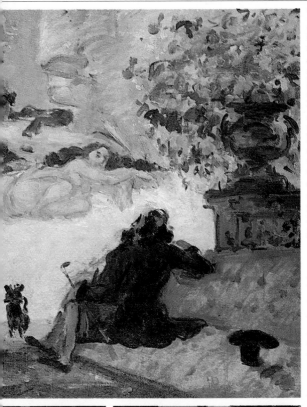

In spite of certain characteristics in common, *The House of the Hanged Man, Auvers-sur-Oise* (opposite) of 1872–3 cannot be confused with landscapes by the other Impressionists. The composition centers around the converging lines radiating from left and right. The edges of the roofs, the walls, and the hillslopes form a series of very precisely connected triangles. In places, the thick pigment is plastered on with a palette knife.

"Don't talk to me about *A Modern Olympia,* there's a good fellow!… Do you remember the *Olympia* of M. Manet? Well, that was a masterpiece of drawing, accuracy, compared to the one by M. Cézanne."

Louis Leroy
Le Charivari
25 April 1874

Above: The second version of *A Modern Olympia* (c. 1873). Left: The first version (c. 1867). Far left: Manet's *Olympia* (1863).

reduced almost to a statue, the heavy curtains—all make a descriptive, anecdotal commentary.

It was the second and very different version, painted five or six years later, that was exhibited in 1874. The composition was now more balanced, with motifs from the first version being repeated but much modified and greatly developed. The green plant became a pot of flowers. The pedestal table and still life were completed. The servant statue came to life, and the hat on the bed and the little dog were outlined with that touch of humor characteristic of the whole work. This painting attracted the most sarcastic remarks at the Société's exhibition. Marc de Montifaud wrote in the

Cézanne in about 1880 (left) and a study for *Three Women Bathers* (c. 1895, below).

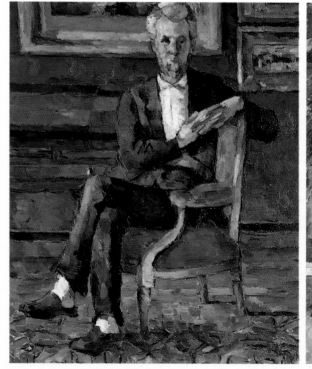

May 1874 issue of *L'Artiste,* "This apparition of a little pink and naked flesh being pushed in an empyrean cloud by a kind of nightmarish demon like a voluptuous vision, this artificial paradise, has suffocated even the strongest-hearted."

Over the next few years, Cézanne, having left Auvers-sur-Oise, divided his time between Paris, L'Estaque, and Aix. Disgusted with the critics, he refused to take part in the Impressionist group's second exhibition in 1876. However, he was much encouraged by Victor Chocquet, a retired customs official and collector of 18th-century art, who shared Cézanne's admiration for Delacroix and owned several of his works. Cézanne must certainly have felt reassured to see his own work—as well as that of Renoir, which Chocquet was one of the first to admire—placed in a historical perspective by a man of taste.

Cézanne was persuaded to participate in the third Impressionist exhibition in 1877. He submitted seventeen works and a portrait of Victor Chocquet that particularly attracted the mockery of the critic of *Le Charivari*: "If you visit the exhibition with a pregnant woman, go quickly past the portrait of a man by M. Cézanne.... This head, the color of boot-tops, looking so peculiar, could give her a dreadful shock and the infant yellow fever before its birth."

But this time the Impressionists found a few champions: novelist and critic Louis-Emile-Edmond Duranty, a friend of Degas'; Théodore Duret, a friend of Manet's, and especially the art critic Georges Rivière, who loudly

" Those who have never wielded a paintbrush or a pencil have said he did not know how to draw and they have reproached him for imperfections which are in fact subtle refinements achieved through enormous skill. "
Georges Rivière
L'Impressioniste
14 April 1877

In a letter of 11 May 1886 to Victor Chocquet (opposite below, a portrait painted in around 1877), an avid collector of modern paintings, Cézanne expresses respect for him and confesses his attraction to the open air. "As Delacroix has acted as intermediary between us, I can allow myself to say this: I would have liked to have the intellectual stability which is your hallmark and allows you confidently to achieve whatever goal is proposed.... Chance has not dealt me the same kind of cards.... Otherwise I have no cause for complaint. The sky, the boundless things of nature always enchant me and give me the chance to look at them with pleasure." Left: *The Pool at the Jas de Bouffan* (c. 1878–9).

proclaimed his admiration for Cézanne's works:
"The ignorant people who laugh at *The Bathers,* for
example, make me think of barbarians criticizing
the Parthenon."

Cézanne's Works of This Period Include the Same Variety of Themes as Before

Only the literary scenes disappear. But the spirit in
which the themes are treated is different. People in the
countryside no longer appear in attitudes expressing
conflict or indifference, but in unison. In certain
paintings, most of which could be called images of
bathers, male and female nudes are harmoniously
linked with the branches of trees or the lines of the
landscape. Cézanne also sometimes places great distances
between his figures: He was seeking a rhythm for this
theme of humanity's unity with nature, at which he
worked ceaselessly.

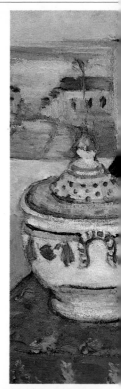

Likewise, in his still lifes there are no more skulls
or burned-out candles. His compositions are formed
of living objects and familiar, simple forms. Flowers
and fruit are placed side by side with fruit dishes,
plates, bowls, and conical milk cans. Some of his still
lifes, a genre that the other Impressionists rarely
attempted, revealed new lines of research that would
become of paramount importance. For example,
Cézanne tried to make a clean break with
traditional perspective. He did this often
in small still lifes, as though he felt more
at ease to experiment in this format.
Larger pictures, such as *Still Life with
Soup Tureen* (c. 1877), are more
revolutionary in the play of reflections
and in the rendering of mass and color
than in their "errors" of perspective.

It was during this stage in Cézanne's
development that the artist and his work
attracted the attention of Paul Gauguin,
who was at that time an amateur painter
and collector of Impressionist works.
The two painters were introduced around
1881 by Pissarro.

Gauguin's collection contained canvases by Monet, Renoir, and Pissarro, which hung alongside works by Honoré Daumier (1808–79) and Johan Barthold Jongkind (1819–91). He owned three works by Cézanne. One of these, the *Still Life with Compotier* (c. 1880) appears in the background of one of Gauguin's own paintings: *Portrait of a Woman* (1890, opposite below). "It is the apple of my eye, and, unless absolutely down to my last shirt, I will hang on to it for dear life," Gauguin wrote to his friend Emile Schuffenecker in June 1888.

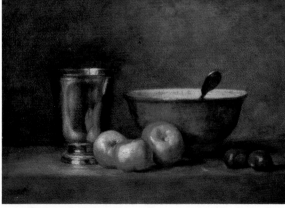

Still Life with Soup Tureen (left above) is said to have been painted at Pissarro's house in Pontoise around 1877. The light on these humble, rounded objects is rendered by a subtle play of reflections. There are almost no shadows. The painting recalls the work of Chardin, ten of whose greatest still lifes had just been acquired by the Louvre. Below left: Chardin's *The Silver Goblet.*

Most of Cézanne's Landscapes Combine Trees With Houses Whose Walls and Roofs Allow the Introduction of Geometric Forms

Whether they depict sites in the vicinity of Paris or in Provence, these landscapes were never based on a single formula. As is true in paintings by the other Impressionists, the imprint of humans can be seen, but the human figure is almost always absent. The viewpoint is often at ground level but at times is placed above, sometimes panoramic, sometimes narrowly focused.

Cézanne always worked on the spot with such precision that the exact place where he had set up his easel can often be identified. His horizon line is usually established much higher up than is traditional (at three-fifths the height of the canvas). Now rid of the fixed perspective of the Neoclassical landscape taught him by Gibert at Aix, he adopted the formulae of the Barbizon School, which did not take much notice of academic rules.

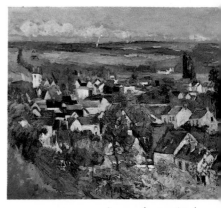

His personality had a strong influence on his choice. In this period even more than in the preceding one, Cézanne started with what lay in front of his eyes, but only in order to interpret it. "I began to perceive nature a little late," he wrote to Zola on 19 December 1878, "though this does not prevent it being full of interest to me." It was then, during his Impressionist phase, that he looked at nature and rendered its changing light with the same fine touch as Monet and Pissarro.

"I Have Begun Two Little Studies with the Sea as the Subject"

The other Impressionists, at least prior to 2 July 1876, when Cézanne wrote this line to Pissarro, had rarely depicted the sea. Once again Cézanne had broken new ground, and this time he suggested that Pissarro follow his lead: "Your letter surprised me on the seashore at

"I am beginning to think myself better than those around me, and you must understand that this good opinion I have of myself has only been reached after great deliberation. I have to work all the time, but not so as to arrive at something polished, which is what fools admire. This thing which is so much appreciated by common people is only the result of a workman's craft and makes any resulting painting inartistic and vulgar. I have to try and achieve my vision only for the pleasure of gaining further knowledge and truth."
Cézanne
letter to his mother
26 September 1874

A bove: *Panoramic View of Auvers* (1873–5).

L'Estaque.... I think the country here would suit you down to the ground.... It is like a playing card. Red roofs on the blue sea."

Cézanne was seeking a landscape that would be the perfect expression of his emotions. The effect of the light reflected off the sea at L'Estaque and the numerous beautiful vistas aroused strong feelings in the painter. He became intent on interpreting nature through color and, as he said, "to become classical again through nature, that is to say, through sensation." This is what Cézanne believed Poussin had also been striving for two hundred years earlier. Cézanne probably knew Poussin's method (according to which style must be appropriate to the subject matter), or he may have intuited its principles simply by standing in front of Poussin's magnificent series of forty paintings in the Louvre. It is not the subject alone but the manner of depicting it that distinguishes a heroic landscape from a pastoral one.

The Sky Is Often Reduced to a Small Light Area or Else Opaque Greenery Hides It Completely

This was the case with two important paintings that formed the beginning and the end of Cézanne's

Below: *Landscape near Médan* (1879–89).

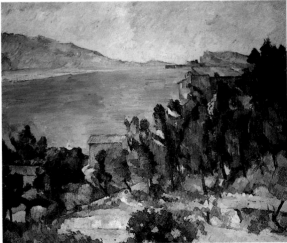

"The sun is so terrifying here that it seems as though objects are pared down to silhouettes.... Wouldn't our gentle landscape painters from Auvers be happy here!"
Cézanne
letter to Camille Pissarro
L'Estaque, 2 July 1876

Left: *Marseilleveyre and Marie Island* (c. 1882).

Impressionist period: *The House of Père Lacroix* (1873) and *The Bridge at Maincy* (1879). The first was painted at Auvers-sur-Oise. The technique is similar to that used in *The House of the Hanged Man.* However, while in the latter precise angles of the edges of roofs and walls are clear-cut in the sunlight, the house of *père* Lacroix is buried in the foliage, which casts its shadow over everything.

As for *The Bridge at Maincy*, it has been possible to date it accurately only through the discovery of the exact site. The painting was already famous, but its location was unknown until a pupil on a school outing near Maincy recognized the bridge. Cézanne had stayed in this region from May 1879 to February 1880 and did not return to it until 1892, when his style was quite different.

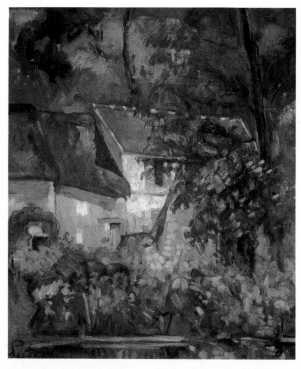

A bove: *The Bridge at Maincy*, 1879.

The House of Père Lacroix (left) is one of the very rare canvases to be signed and dated (1873). Cézanne signed only about twenty and dated only about ten of his works, making it difficult to establish a precise chronology.

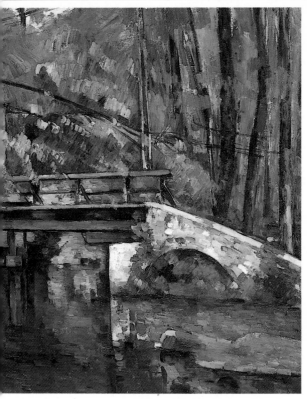

"Setting the bridge squarely in the centre of the picture, and employing its two prominent arches as framing elements, [Cézanne]…proceeds to align the foreground trees with the bridge itself—not least by making the reflection of the arch at the left so distinct that it presses forward to link these two spatial planes. Enhancing this under-lying symmetry are the changing hues of the water, which appears deep green in the centre and russet brown to either side. In his treatment of the foliage above, however, Cézanne employs a modulated range of emerald greens and whites in mosaic-like touches which evoke the play of dappled light over this enchanting scene and reveal the extent of his debt to his Impressionist years. The result is a picture which combines the richness of interest Cézanne experienced before nature and the 'well balanced' lines disapproved of by Gibert…. It is a kind of Impressionism made classical—one which possesses the authority of the art of the Old Masters and the optical concerns of Cézanne's own generation."

Richard Verdi
Cézanne, 1992

This composition of still water enclosed and nearly choked by vegetation is much closer in its wild poetry to the Château Noir paintings of around 1900 than to other landscapes of the period 1878–80. It was one of the few paintings to be copied and sold during Cézanne's lifetime. The dark mass of greenery in the *The Bridge at Maincy*, like that in *The House of Père Lacroix*, recalls certain landscapes by members of the Barbizon School.

Cézanne Painted Some Twenty Portraits in Eight Years, Half of Which Are Self-portraits

Like the other members of the Impressionist group, Cézanne painted few portraits. The Impressionist

The Bridge at Maincy

"[Cézanne] never applied a brushstroke that had not been deeply thought out beforehand. He knew what he was doing and what he wanted. He had the secret of presenting our eyes with delicate sensations."
Emile Bernard
Souvenirs sur Paul Cézanne, 1921

technique required that great attention be paid
to surface color, and thus a model's personality was
necessarily relegated to second place. Cézanne
did, however, experiment with several portraits
of himself.

Cézanne did not flatter himself in his portraits.
The choice of unusual hats—a cotton turban, a hauler's

Cézanne often drew
portraits of his son
in pencil because he
could not make the child
stay still long enough to
paint him. Below are
sketches of young Paul at
the age of six or seven.

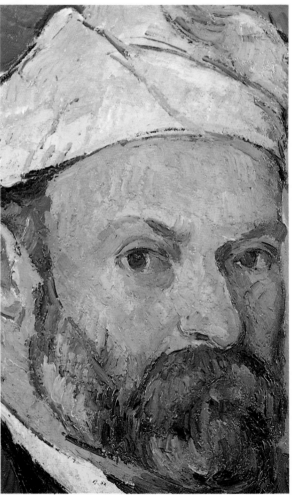

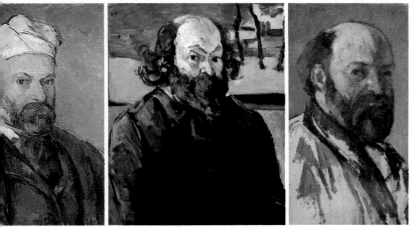

cap, or a gardener's hat—at a time when wearing
a formal hat was the rule, underlined the antisocial
character Cézanne affected. Cézanne was, as the
critic Louis Vauxcelles once observed, "a legendary
figure, with a coarse, bristly face, his body wrapped
in a hauler's rough woolen greatcoat. But this Cézanne
is a master."

In Cézanne's self-
portraits the painter
presents himself without
any flattery. He tries to
depict physical reality
rather than psychological
expression. From left to
right above: Three self-
portraits dating from
around 1880, 1875, and
1877–8, respectively.
The last one once
belonged to Pissarro.

 In 1878 and 1879 Cézanne made several lengthy stays
at Aix and L'Estaque, whereas in previous years he had
spent much more time in and around Paris. This
withdrawal from the public life of the city and isolation
from the Paris artistic community helped to accelerate a
change in his working method. The views of L'Estaque
that date from these years depart radically from
Impressionism.

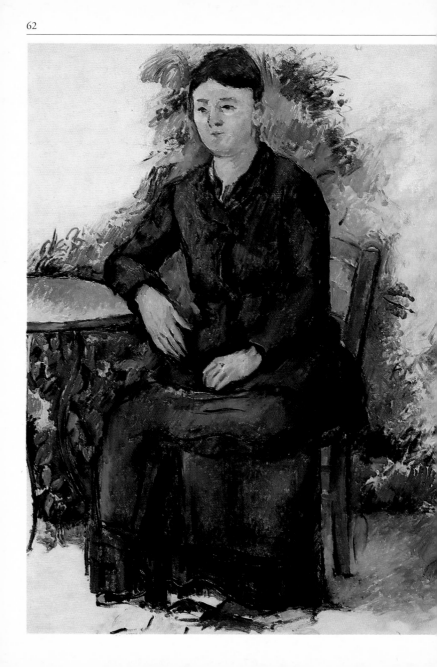

I am using all my ingenuity to find my true path in painting," Cézanne confided to Zola on 24 September 1879. After seven or eight years of using Impressionist techniques, he probably thought he had pushed the analysis of luminous reflections and colored shadows to the limit. But if there was a distinct development in the artist's output of around 1880, it was not a sudden abandonment of old processes but a gradual distillation of styles.

CHAPTER III
"A HARMONY PARALLEL TO NATURE"

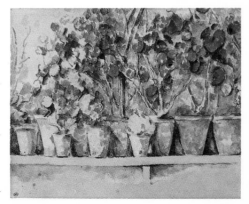

In the watercolor *Flowerpots* (1883–7, right), the supple stems and the vibrant quality of the light reduce the uniformity of the line of pots. Cézanne explored a completely new mode of expression in watercolor. Few of his French predecessors had given the medium such a central role in their work. Opposite: *Madame Cézanne in the Garden* (1879–82).

Cézanne Was the First to Venture Beyond Impressionism, But He Did Not Break with It Completely

Cézanne remained and would always remain faithful to certain principles of this movement—in particular, working outdoors and rendering shadows in color. The modification of the colors of an object—whether an apple or a mountain—in terms of the light that illuminated it (one of Impressionism's major discoveries) remained one of the foundations of Cézanne's work both in his oil paintings and in his watercolors after 1880, and was a technique he employed more and more frequently. And even in his most Impressionistic paintings, Cézanne had always kept a sense of form. His compositions, especially his landscapes, are always very carefully constructed.

Other Members of the Group also Felt the Need for Renewal

It was perhaps through observing Cézanne's development that the other Impressionists started on a strict diet of austerity. Renoir called the period when he gave up smothering his shapes in variegated patterns of cotton-wool "Ingresque." His contours became more well-defined and his colors brighter and sharper. A little later, Monet painted several large canvases in which women in

Cézanne found the peace and quiet he loved at the Jas de Bouffan. He depicted its buildings (opposite, *House and Farm at the Jas de Bouffan,* painted in 1885–7), the ornamental lake, and the park and its trees throughout the seasons. He made peasants and laborers pose for him in the garden. In 1899, two years after his mother's death, the property was sold at his sister's insistence. Before he moved out, Cézanne burned most of his possessions.

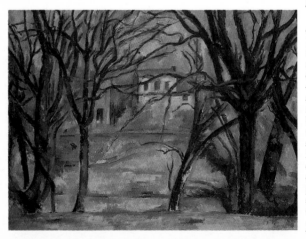

The light, thin pigment and delicate coloring of *Trees and Houses* (1885–7, left) call to mind the watercolorist's craft. The composition —a bright open space surrounded by a dark mass of intertwined branches—is one of the most symmetrical in all Cézanne's work. Was he casting a glance in the direction of traditional classical landscape painting taught by his art master Gibert? Opposite below: *Trees and Roof* (c. 1882–3).

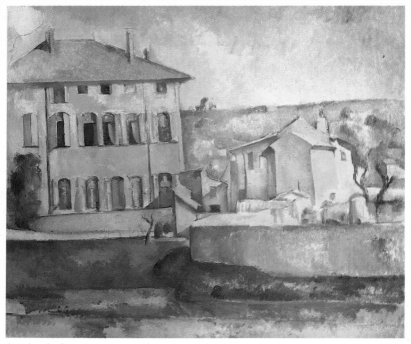

bright clothes sitting in rowboats suggest a new conception of space. Even Pissarro was soon to bow to strict Neo-impressionist disciplines.

Cézanne's development did not, however, bring about any cooling of relations with the other members of the group. He stayed more and more often in Aix or L'Estaque, but continued to visit Pissarro whenever he returned to Paris. In the spring of 1882 Renoir came to stay at L'Estaque, where he was warmly received by Cézanne. The following year Renoir came again, this time in the company of Monet. And during the summer of 1885, Cézanne spent time at Renoir's home at La Roche-Guyon near Paris.

Square and Triangular Brushstrokes

In paintings executed during his Impressionist period, Cézanne's heavy

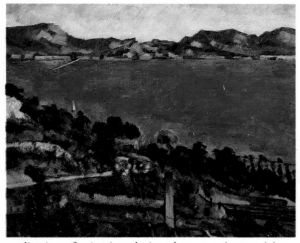

application of paint (a technique known as impasto) is at times so thick and gritty that it invites comparisons with the work of Chardin. In other paintings it is more fluid and appears to have been applied with long comma-like brushstrokes. After 1880, Cézanne's technique developed in a different direction. He sometimes placed his touches of paint like square pieces in a mosaic. The pigment remains rather liquid and does not always entirely cover the white canvas. In his views of L'Estaque, the abandonment of perspective and flattening of the planes is particularly noticeable. The sea is reduced to one huge glossy surface, while the painter uses a heavy impasto for the rocks.

"I Paint as I See and as I Feel, and I Have Very Strong Feelings"

There was a contradiction between Cézanne's profound innovations and his seemingly traditional method of work. The artist never stopped working from nature, whether creating a still life, a portrait, or a landscape. He said he was always on the lookout for beautiful subjects, and many critics have emphasized his lack of imagination and denigrated the so-called "realist" character of his art. This word can be taken in many ways and has caused much misunderstanding among

"A southern seascape, ponderous blue water, craggy hills, the stupor of things in the heat, strongly composed landscape, all executed with exceptional care and frankness."
Gustave Geffroy
Le Journal
16 February 1894

Above left: *The Gulf of Marseilles Seen from L'Estaque* (c. 1879). Above right: *Bay of L'Estaque* (1879–83). Opposite: *View of L'Estaque and the Château d'If* (1883–5).

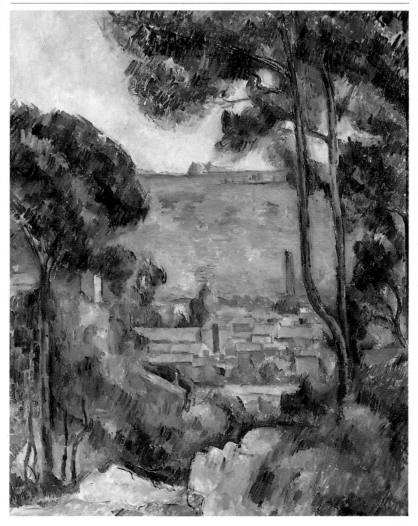

historians. The creation of a new kind of spatial
structure, which Cézanne only fully developed after 1895,
was the result of obstinate individuality. Observation of
reality was only the point of departure for a highly
subjective form of painting.

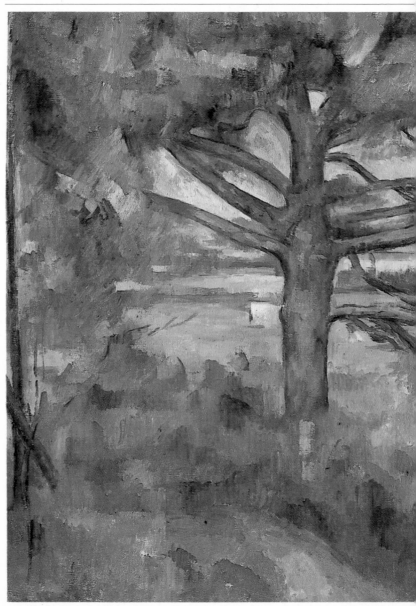

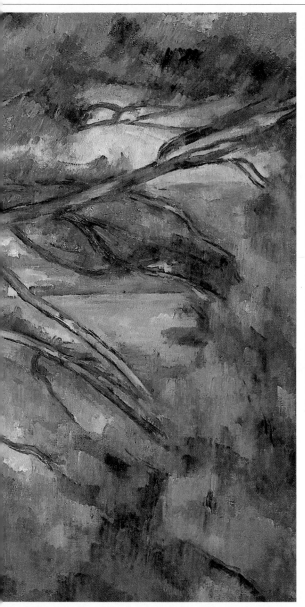

Cézanne often isolated a tree in the foreground of a panoramic landscape. But here, in *The Great Pine* (c. 1885), the tree commands all the attention and almost entirely hides the landscape; it is difficult to make out a few patches of earth and sky through the network of branches. Cézanne was no longer trying to render the texture of bark, vegetation, or land. He gave unity to his landscape by using a uniform treatment of hatched brushstrokes, a technique similar to that used in watercolor. The choice of gold for the intersection of the two strongly indicated vertical and horizontal axes accentuates the monumental character of the work. Without being grandiose, this painting is imbued with the quasi-religious spirit Cézanne often gave to his country landscapes.

After 1880 Cézanne's Drawing Became "Heretical," in Comparison to Standard Practices of the Day

Fruit dishes and bottles are no longer truly vertical, the edges of tables no longer protrude from the folds of the drapery partially obscuring them, apples are balanced on a chest's sloping lid. Until this time it was generally understood that a painting represented a fragment of reality (static or moving) as seen by a painter-observer who was motionless. Manet, Degas, and Renoir had discreetly ignored this rule, but in such a way that these dual points of view would only appear as a result of analysis. Cézanne, however, multiplied the viewpoints in an immediately obvious way. Glasses and fruit dishes are depicted simultaneously from two or three angles: from the front, from top to bottom, and from the side. This manner of representing an object or a vista is now referred to as constructivism.

Over the years this multiplicity of viewpoints would be joined by many other "heresies": disruption of scale, fragmentation of form, dissociation of drawing and color, and the introduction of abstract elements to fill out a composition. Cézanne first used still lifes as a chosen vehicle for his formal experiments, then later extended these "errors" to all of his works.

M ost of the objects in *Kitchen Still Life* (1888–90, below) are seen from two or three different viewpoints.

Cézanne Said He Had Found "a Good Formula" for These Harmonious Still Lifes

The still lifes of Cézanne's constructivist period bear little resemblance to, and do not really derive from, the dark dramatic still lifes of the artist's early years or the fleshy depiction of gleaming objects from the years around 1875. Cézanne assigns a place to each object and each spot of color to render a totally harmonious whole. He had found his own personal style by painting in oils and watercolor. There is no sense of difficulty in these works. Not only

"Cézanne's genius is to arrange the whole picture so that the distortion of perspective ceases to be visible in itself when one looks at it as a whole, and only gives the impression, as in normal vision, of a new order being born, of an object in the act of appearing, in the act of coming together in front of our eyes."
Maurice Merleau-Ponty
Sense and Non-sense
1948

do they satisfy the eye and spirit, but they also reward formal or thematic analysis.

Freed from Influences

This break with the conventions that had been established as long ago as the Renaissance led to the invention of a new spatial structure. Cézanne was not the only painter to attempt this, but he was the earliest, and he took it further than anyone else. Influences that might have led him to take this step have been sought, but in vain. Certainly Cézanne must have seen examples of art that did not derive from the Italian Renaissance tradition at Aix, in Paris, or in the illustrated periodicals proliferating at the time. He could have been inspired by these just as Gauguin and Van Gogh were. The abolition of traditional perspective and the use of planes placed behind objects are systems of space representation that are very similar to those used in Romanesque frescoes or in Japanese prints. However, there is no conclusive evidence whatsoever to prove that Cézanne was interested in these or that he might have turned his attention in this direction.

In 1879 the Musée de Sculpture Comparée (later to become the Musée des Monuments Français) opened in Paris. It exhibited many plaster casts of ancient French and foreign sculptures. Cézanne went to this museum frequently, but he does not seem to have visited the Musée d'Ethnographie (now the Musée de l'Homme), where he might have seen examples of African and pre-Columbian art.

On the other hand, he worked at the Louvre all his life. There he focused primarily on the magnificent works of Renaissance sculptor Michelangelo (1475–1564),

The Blue Vase (1885–7) is one of the most well known canvases of Cézanne's middle period. In this painting the artist creates an autonomous pictorial space from a composition made up of disparate objects, each charged with symbolic meaning. It is difficult to say if the lines on the right represent a window or part of the wallpaper. Color contributes to the unity of the canvas and lights up the shadows, even though Cézanne deliberately neglects to indicate exactly where the light comes from.

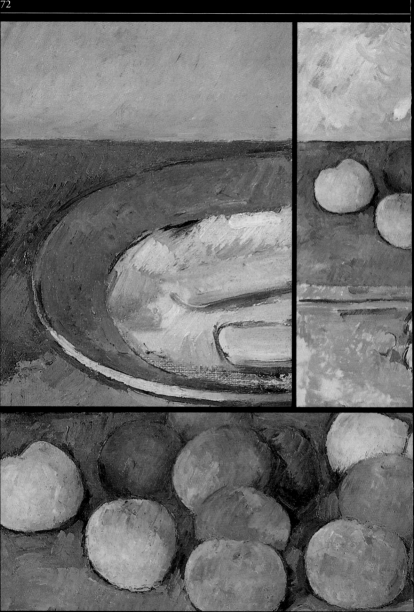

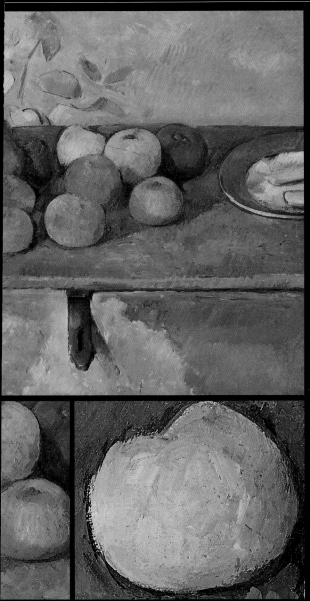

Apples and Biscuits

One of the simplest still lifes of Cézanne's mature years, *Apples and Biscuits* (1879–82) best sums up the essential character of the art he produced in his most serene period. To create a perfectly coherent composition, a plate and some apples on a chest were enough. The delicacy of the colors rendered in watercolor shades (pink for the biscuits and pale blue for the plate), the feigned simplicity of the arrangement, and the subtle use of the space around a few simple objects are treatments previously found only in the work of French painter Lubin Baugin (1610–63) or Spanish painter Francisco de Zurbarán (1598–1664), though it is unlikely that Cézanne had seen their still lifes.

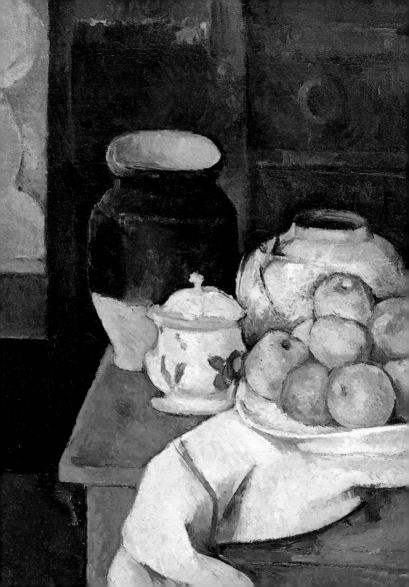

Apples from Childhood

Apples have a prominent place in Cézanne's stylistic experiments, and the fact that he repeatedly chose this fruit is significant. For Cézanne, above and beyond their traditional erotic symbolism, apples were representative of his early struggles. The young Zola became a childhood friend when the future painter protected the future novelist from school bullies, and Zola gave him apples in gratitude. Cézanne later painted numerous still lifes of apples. He wanted, he said, "to conquer Paris with an apple"—in other words, to become well known as a painter of a subject that was at once both trivial and full of meaning.

Left: *Still Life on a Table* (1883–7).

but he was also attracted to ancient sculpture and occasionally to works dating from the Middle Ages.

Cézanne's field of interest was wider in painting, but the artists he studied most intensively were Peter Paul Rubens (1577–1640) and Delacroix. Altogether, nearly a third of the drawings preserved by Cézanne (there are very few copies in oil) were copies of works of art.

Cézanne felt an affinity with the dramatic genius of 17th-century French sculptor Pierre Puget and made several drawings from his works, including this *Milo of Crotona* (1882–5).

During the Constructivist Period, Cézanne Painted L'Estaque and Its Vicinity over Twenty Times

The painter described his house in a letter to Zola of 24 May 1883: "I have a little house and garden here just above the station at the foot of the hill where the rocks and pines begin to rise behind me. I am always busy with my painting, I have some fine viewpoints here." Usually he brought together sea, mountains, houses, greenery, and occasionally—an unusual detail that he was without a doubt one of the first to dare to paint—a factory chimney. The sea is reduced to a kind of lifeless, motionless blue sheet. This reduction of the sea to a flat plane contrasts strongly with the surrounding greenery and houses, which Cézanne readily cuts up into geometric shapes. In the canvases painted during his early stays, the vegetation is most often thick and bushy, combining varied hues of green and yellow. Later the representation of the site is the main consideration. The artist even convinced Renoir to visit L'Estaque. Renoir had never worked in that region before and is known to have been charmed by "this beautiful country."

Trees and Buildings Etched with Distinct Contours on the Canvas

In the 1920s, after the advent of Cubism, many studies of Cézanne would dwell on the geometric lines or grids to which his paintings could be reduced. Certainly the rectilinear sharp edges of the Jas de Bouffan or the staggered tiers of roofs at

Gardanne, a village near Aix, lend themselves to this kind of interpretation. It was in 1885 and 1886 that Cézanne found a source of inspiration there, as he describes in a letter to Zola of 25 August 1885: "I am beginning to paint at last because I have almost no worries. I go to Gardanne every day and I come back every evening to the country, to Aix." Cézanne here speaks revealingly of the two conditions necessary before he could create a work of art: tranquillity of mind and a stimulating scene. The contours of trees and houses in his Impressionist period had been swathed in or shaken by a kind of vibration. But after 1880 the light in Cézanne's landscapes changes completely. It becomes a hard uniform light that, unlike Impressionist light, is not analyzed in a systematic way. It is impossible to tell the time of day or the season of the year.

Cézanne's Father Intercepted a Letter from Chocquet to His Son and Discovered That His Son Was Living with an Artist's Model and That the Couple Had a Child

In 1878 Cézanne came to L'Estaque again looking for a refuge for Hortense Fiquet and their son Paul. He persisted in keeping this liaison from his father. When his father discovered the truth and confronted his son, the artist denied that he was having an affair. Furious at being lied to, Louis-Auguste reduced Cézanne's allowance by half. For several

Even when their relations were difficult, Cézanne always showed deference to his father (below). His parents did not attend the wedding ceremony for his marriage to Hortense Fiquet at the Church of Saint-Jean-

Baptiste at Aix-en-Provence on 29 April 1886, but they were present at the civil ceremony the day before, and they signed the marriage license (above) at the town hall in Aix.

months Cézanne was thus obliged to take advantage of the generosity of Zola, who, because of his success with his novel *L'Assommoir,* was now quite well off.

Relations in the Cézanne family became strained. Louis-Auguste pretended not to know what he did in fact know: "It seems I have some grandchildren in Paris; I'll have to go and see them some day," he is said to have remarked to a friend. The painter found allies in his mother and, though this is less certain, his sister Marie—although neither much liked Hortense. They nevertheless joined forces in 1885 to brush aside a woman with whom the painter was reputed to be having an affair, though little else is known about this event.

Paul would marry Hortense on 28 April 1886. He was then forty-seven years old and his son fourteen. Louis-Auguste had finally given his consent to the marriage, but he died a few months after the ceremony.

Cézanne Began to Work on the Mont Sainte-Victoire Series, the Most Famous of All His Motifs

In a letter of May 1881 Cézanne told Zola: "I have begun several studies [of the mountain], some in overcast weather, some in full sunlight." Some ten years later Monet would adopt this method of working with his Haystacks

Zola in his study at Médan, in a photograph taken around 1897 (opposite).

Cézanne helped succeeding generations of artists to discover Mediterranean light. At L'Estaque Cézanne was visited by not only Monet and Renoir, but Georges Braque (1882–1963) and Raoul Dufy (1877–1953). Above: *The Gulf of Marseilles Seen from L'Estaque* (1883–5). Left: *Self-Portrait* (1880).

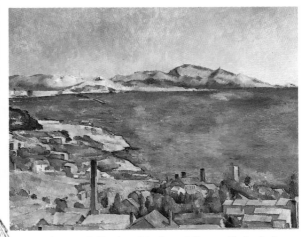

(1890–1), Poplars (1891), and Rouen Cathedral (1892–4) series, his views of the Thames in London (1900–4), and at the beginning of the century, his Waterlilies.

Mont Sainte-Victoire, a mountain that dominates the countryside around Aix, appeared for the first time in about 1877 as a picture within a picture in *The Eternal Feminine* (also known as *The Triumph of Women*). It was only after 1880, however, that Cézanne became passionately obsessed with "his" mountain.

In paintings created in the 1880s, the mountain usually appears in the background of a very structured landscape with tiers of planes, depth being suggested by a tree in the foreground and by a series of horizontal and oblique lines. The

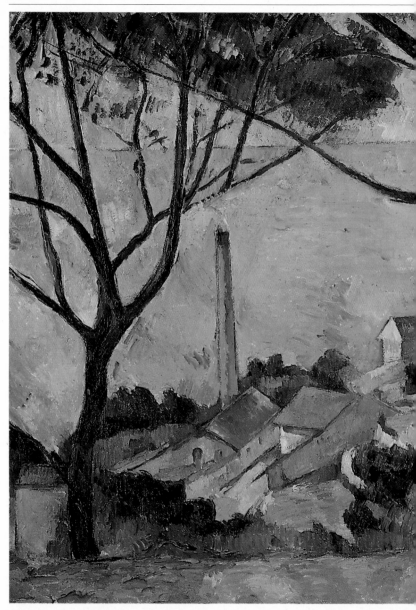

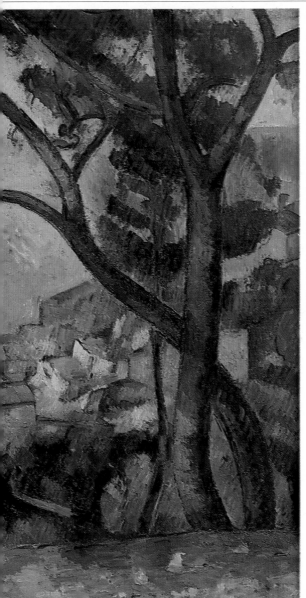

The Sea at L'Estaque

Cézanne rarely
painted the sea
except at L'Estaque (a
painting of 1883–6, left).
Cézanne eventually
stopped going there
for several reasons,
including the increasing
industrialization of the
place. Cézanne mused
in a letter written to
his goddaughter on
1 September 1902: "I
remember perfectly the
once so picturesque
coast of L'Estaque.
Unfortunately, what is
called progress is nothing
but the invasion of
bipeds who will not rest
until they have
transformed everything
into hideous quais with
gas lamps and—what
is even worse—with
electric lights. What
times we live in!"

light is clear and even; the atmosphere limpid. As in his still lifes, Cézanne presents an image of a world at peace in his imposing panoramas.

Mont Sainte-Victoire Showed the Painter Dominating His Surroundings

Sites in the vicinity of Aix had of course often been an inspiration for Cézanne, but he had only occasionally painted panoramic views. Mont Sainte-Victoire, its colors changing by the hour, made its appearance in the artist's canvases as he began to spend less and less time in Paris and more in Aix. His relations with his father had become more relaxed, he no longer had money worries, and he had finally legalized his domestic situation by marrying Hortense Fiquet.

The serenity of these landscapes can be seen as a reflection of the new calm in his family life, and the dominating position of the mountain as the symbol of Cézanne himself taking possession of his territory and triumphing over the people of Aix, who had not wanted to recognize his artistic talent. In the 19th century Aix-en-Provence was a sleepy little town of about 30,000 inhabitants. In the Middle Ages it had been the capital of the Provence region, but in 1789 it was usurped by its rival Marseilles and retained only the court of appeals,

Compared to Monet's or Sisley's poplars, shimmering in the sun, Cézanne's have the solidity and immobility of bronze. This luminosity, this improbable positioning of shadows, is especially marked in the majestic landscapes dating from 1885 to 1890. Here Cézanne achieved the same poetic serenity as that evidenced in Poussin's heroic landscapes. Opposite above: Cézanne's *Poplars* (1879–82). Below, from left to right: Details of Monet's *Poplars* (1891); Sisley's *Moret, Beside the Loing* (1892); and Cézanne's *Poplars*. Below, far right: Monet's and Sisley's complete pictures.

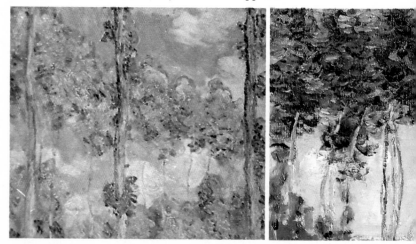

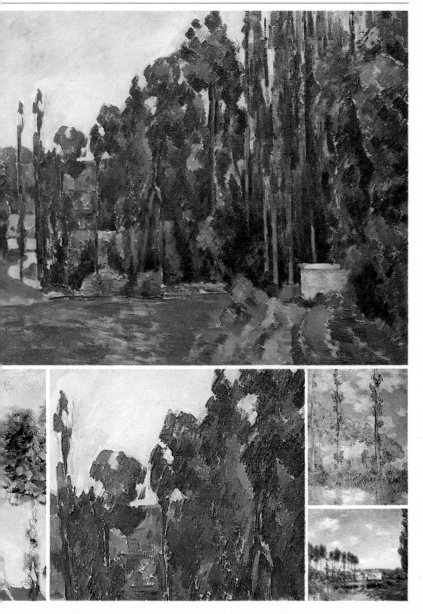

the archbishop's palace, and the university as marks of its former position. As a student Cézanne had endured the quiet life in Aix, escaping on jaunts with Zola and Baille whenever he could. As a painter he bitterly felt his fellow citizens' lack of understanding of his work. Even so, its provincial calm was probably not unpleasing to the solitary artist.

Emile Zola, Cézanne's Life-long Friend, Did Not Understand Cézanne's Talent any More Than the Painter's Father Did

For Cézanne, Zola represented a mixture of people: the close childhood friend, the young art critic and champion of the new style of painting, the successful writer who loaned him money when his own father withheld his allowance, the good friend whose opinions he respected, and someone he counted on to recognize the worth of his painting. Cézanne had often asked favors of Zola, who had always helped his friend very willingly. But in 1886 the painter and the novelist had a serious row.

Zola had often defended Manet and his circle in his critical reviews, but he seems to have understood and appreciated both the Impressionists' and Cézanne's Neo-impressionist art more for its modernity than for anything else. As the years went by, his articles on the Impressionists became more and more reserved and his support for the efforts of the group, including Cézanne's, less and less enthusiastic.

There is evidence of this in a letter written by writer and critic Joris-Karl Huysmans to Pissarro in 1883, written in reply to this query from the master: "Why is it that you do not say a word about Cézanne, whom all of us recognize as one of the most astounding and curious temperaments of our time and who has had a very great influence on modern art?" Huysmann's response: "I find Cézanne's personality congenial, for I know through Zola of his efforts, his vexations, and his defeats when he tries to create a work!"

Zola's declarations about aesthetics, his taste for heavy and ostentatious furniture, and the fact that he had taken down almost all of his friends' paintings from his walls confirmed where his beliefs lay.

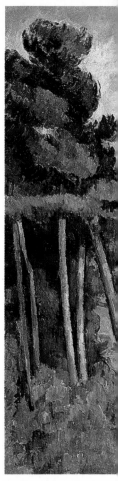

Mont Sainte-Victoire belongs to a family of "sacred" mountains that also includes Sinai, Tabor, and Olympus. Its name, whose origins are disputed, gives it a domineering and venerable aspect.

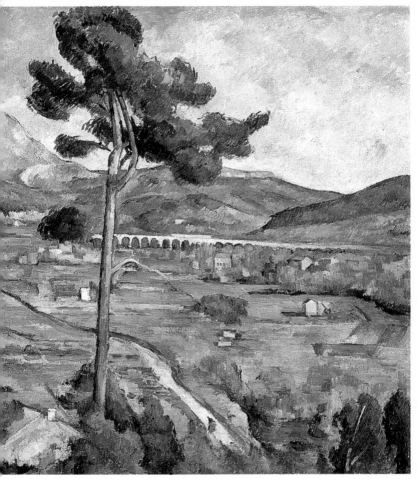

The Publication of Zola's *L'Oeuvre,* in Which Cézanne Recognized Himself in the Character of Claude Lantier, "a Failed Genius," Was the Cause of the Rift

In 1886 Zola—as was customary on the publication of one of his new novels—sent a copy of *L'Oeuvre* to Cézanne. Zola's supporters said it was never the author's intention to feature his friend in the book, but his contemporaries recognized Cézanne in the

This view of Mont Sainte-Victoire was painted around 1885. A lone pine in the center of the composition is a bold and unorthodox way of giving depth to the landscape.

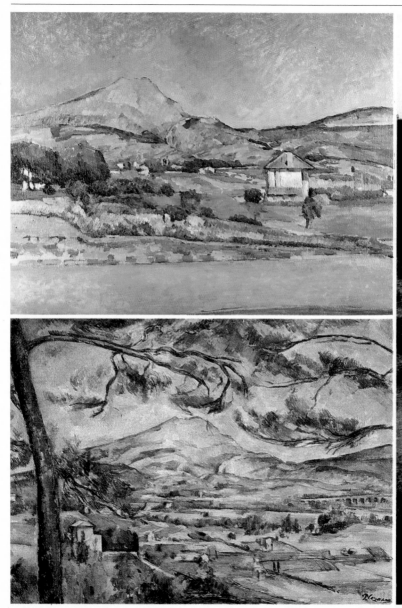

"You see the mountain well before [the town of] Le Tholonet. It is bare and almost monochrome, more a flash of light than a color. Sometimes the shape of the clouds can be confused with high mountains: Here it is quite the reverse; the dazzling mountain at first sight seems to have emerged from the sky. This impression is reinforced by the movement of the rocky flanks falling in parallel folds as though petrified in an age before time or extending horizontally at the base of the mountain. The mountain seems to have flowed from on high, from the almost identically colored sky, and to have thickened here into a little massif from universal space."

Peter Handke,
*The Lesson of
Sainte-Victoire*,
1980

Opposite above: *Mont Sainte-Victoire* (1882–5). Opposite below: *Mont Sainte-Victoire* (1885–7). Left: Early 20th-century photograph of the road between Le Tholonet and Mont Sainte-Victoire.

portrait of this unsuccessful painter.

If Zola's portrayal of Cézanne was unintentional, it makes it all the more revealing. From Zola's standpoint, Cézanne had become a disappointment as an artist and an embarrassment as a friend. In fairness it should be noted that often at Zola's home in Médan, where

Cézanne's portraits of Hortense Fiquet, with their clear, simplified volumes, were of particular interest to the Cubist painters.

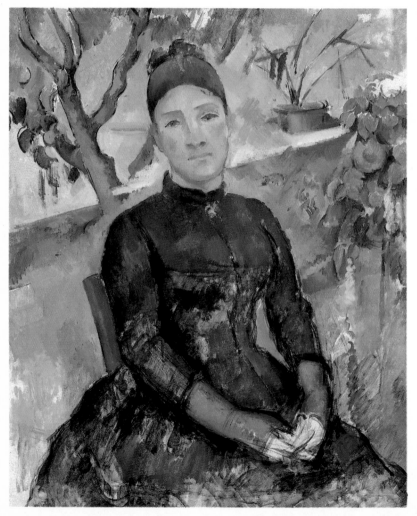

Cézanne had enjoyed Zola's hospitality since 1878, he had behaved inconsiderately to both the writer and his other houseguests.

On 4 April 1886 Cézanne wrote a very curt yet dignified letter of thanks to Zola that put an end to their long friendship. The two men were never to see each other again.

Madame Cézanne and Young Paul

There are many pictures of Hortense Fiquet from the last decade of the 19th century. The features of her face are usually vague and inexpressive or else the expression is solemn and

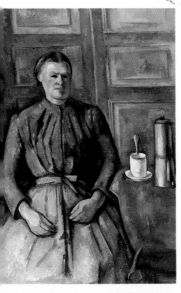

Mardi Gras (1888, top) is one of the very few paintings after 1870 that include figures in motion. Above center: Studies for *Mardi Gras* (1888). Above: *Louis Guillaume in Pierrot Costume* (1888). Left: *Woman with a Coffeepot* (1890–5). Opposite: *Madame Cézanne in the Conservatory* (1891–2), the famous portrait of Hortense, whose grace and elegance is only enhanced by the painting's unfinished state.

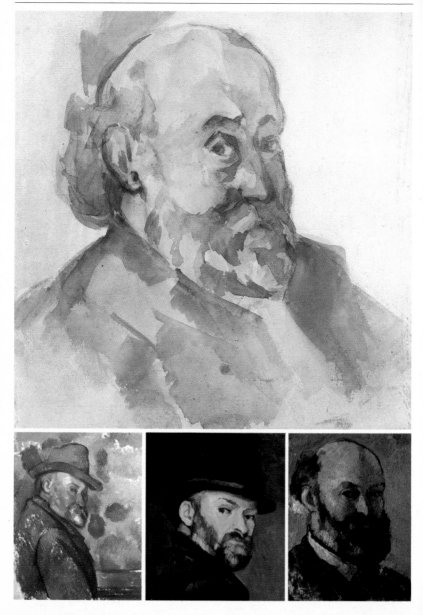

Cézanne's self-portraits are the most lively and the most spontaneous of all his portraits. Opposite top: *Self-Portrait* (c. 1895). Opposite below, from left to right: *Self-Portrait in a Soft Hat* (1890–4); *Self-Portrait in a Bowler Hat* (1883–5); *Self-Portrait* (1879–82), a work that once belonged to Degas. Left: Details of Cézanne's own eyes.

thoughtful. Certain strongly structured portraits of her also date from the end of this classic period, as well as *Woman with a Coffeepot* (1890–5), where the body and objects are simplified into geometric lines. The model for this canvas is not known for certain, but is thought to have been Madame Brémond, the painter's housekeeper.

After 1880 young Paul's face also appeared in a few paintings. In 1888 he sat for a huge composition entitled *Mardi Gras,* which was inspired by a traditional carnival held at Aix-en-Provence. Cézanne's son was very fond of his father and was an emotional support to him at the end of the painter's life.

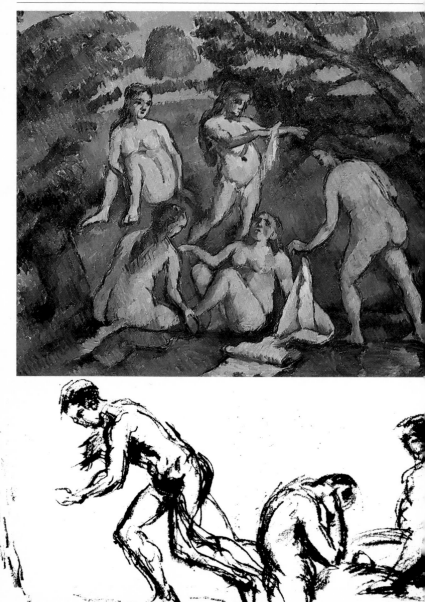

The Bathers Series

Compared to both his academic and revolutionary contemporaries, Cézanne's output was striking for the richness and diversity of its themes. Certain genres, however, seemed to go through a period of slow ripening rather than sudden fruition. This is so with the theme of the bathers that Cézanne began to explore in the late 1870s. Many of these paintings were modestly sized sketches or rough drafts, which Cézanne clearly intended to develop further at a later time. The fact that they were experimental works perhaps partially explains why so many artists (including Monet, Henri Matisse, Pablo Picasso, and Henry Moore) were so eager to acquire them. The theme of nude bathers out of doors would occupy Cézanne for thirty years, to the end of his life. The puzzles of composition and rhythm that he struggled with in the early versions would ultimately be worked out, and what Cézanne learned from these exercises would be applied to all his other work—whether still lifes, portraits, or landscapes.

Opposite: *Five Bathers* (1879–82, above), a painting that once belonged to Pablo Picasso, and *Three Bathers* (1887–90, below).

Below: *Male Bathers* (1890–4).

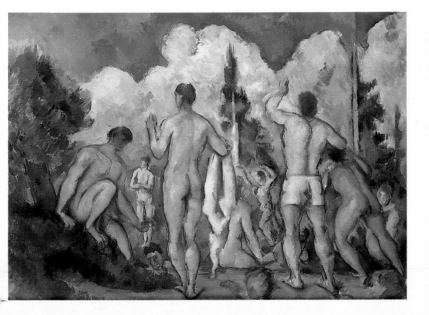

Cézanne had followed a difficult road, guided only by his inner convictions. He had overcome much opposition, and his work had opened up new paths in painting. However, in January 1903 he confessed modestly to art dealer Ambroise Vollard: "I have made some progress. Why so late and with such difficulty? Is art indeed a priesthood that claims the pure in heart and takes them over completely?"

CHAPTER IV
"I BEGIN TO SEE THE PROMISED LAND"

Whether a still life, figure, or landscape, Cézanne treats all motifs with spirit and freedom. Opposite: *Vallier Seated* (c. 1906). Below: *Still Life: Apples, Pears, and Pot* (1900–4).

The Death of His Father Made Cézanne Wealthy, But He Continued to Lead a Simple Life in Aix

It is easy to think that Cézanne would have seized this opportunity to travel to Italy or Belgium to see works by the masters he had so admired in the Louvre, or, like Monet and Degas, to form a collection. But instead he kept to his very simple lifestyle. Apart from visiting the spa at Vichy (he suffered from diabetes), making a visit to Switzerland at the behest of his wife—"she likes only Switzerland and lemonade," he once noted—and a few increasingly brief trips to Paris, he hardly left his favorite place: Aix and the surrounding region.

At Aix Cézanne led a life of routine, spending more time in the company of his sister than that of his wife and son, who preferred to stay in Paris. He became a practicing Catholic and was a frequent worshiper at the cathedral. He painted almost every day, either driven by carriage to a particular site or painting at home. In 1902 he set up a new studio on the road to Les Lauves, in the immediate vicinity of Aix, which overlooked the town and had a good view of Mont Sainte-Victoire.

In November 1895 Ambroise Vollard Organized the First Exhibition of Cézanne's Work

Cézanne had shown a few canvases in group exhibitions, but the shop of Julien Tanguy—an enterprising paint dealer in the Parisian neighborhood of Montmartre who took paintings in exhange for paints and other artists' supplies—was the only place his work could be seen.

The painter Maurice Denis (1870–1943), who executed a solemn *Homage to Cézanne* in 1900, admitted that toward 1890, at around the time of his first visits to Tanguy's shop, he believed that Cézanne was a myth, perhaps even the pseudonym of an artist engaged in other research but whose actual existence he doubted.

It was also at Tanguy's that Ambroise Vollard (a young Creole recently established as a Paris art dealer) saw some paintings by Cézanne for the first time. Gifted with exceptional flair, the novice dealer organized the first solo exhibition of Cézanne's work. From then on Vollard dedicated himself to making his protégé's work known,

"Vollard poses every morning at Cézanne's and has done so for an age. Whenever he moves, Cézanne complains that he makes him lose his train of thought. He also talks about his own lack of optical qualities, and of his inability to realize his vision like the old masters; but he believes himself to have feelings," wrote painter Maurice Denis in his diary. Ambroise Vollard was to say in 1914, "It is difficult for anyone who has not seen him paint to realize just how slow and laborious his work was on certain days." After 115 sittings—again according to Vollard —the painter returned to Aix. Above: A photograph of the Trois-Sautets Bridge in the vicinity of Aix.

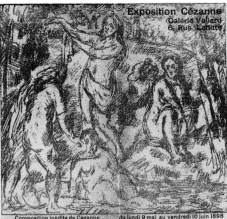

and he personally bought the major part of the artist's output.

In 1895, after difficult negotiations, two of Cézanne's paintings, *Farmyard at Auvers* (c. 1879) and *The Gulf of Marseilles Seen from L'Estaque* (c. 1879) entered the Luxembourg Museum as part of the bequest of painter Gustave Caillebotte (1848–94). Caillebotte had been a generous supporter of the Impressionists and—like Monet, Degas, Renoir, and Gauguin—had much admired Cézanne.

Young Painters Revere Cézanne, Painters and Critics Write About Him, Some Visit Him at Aix

In spite of his reputation for unsociability and his phobia about physical contact —he is reputed to have flown into a rage when inadvertently touched—Cézanne received his admiring visitors amiably and even kept up a correspondence

Portrait of Ambroise Vollard (1899, above) and the catalogue for an exhibition in Vollard's gallery in 1898 (top).

with some of them. Such was the case with two young painters, Charles Camoin (b. 1879) and Emile Bernard (1868–1941). It is in a letter to Bernard of 15 April 1904 that Cézanne wrote these now-famous sentences: "See in nature the cylinder, the sphere, the cone, putting everything in proper perspective, so that each side of an object or a plane is directed toward a central point. Lines parallel to the horizon give breadth, that is a section of nature, or, if you prefer, of the spectacle which the *pater omnipotens aeterne deus* [almighty father eternal god] spreads before our eyes. Lines perpendicular to this horizon give depth."

The importance of these phrases, often seen as a watershed in 20th-century painting because they appear to contain the seeds of Cubism, has probably been exaggerated. Cézanne had a tendency, because of his good nature, to adapt his written or spoken answers to his audience. He considered Bernard to be, as he put it in a letter to his son of 26 September 1906, "an intellectual saturated with memories from museums." And it must be said that Cézanne, a little mischievously, appears to have learnedly formulated a theory that simplified everything for him.

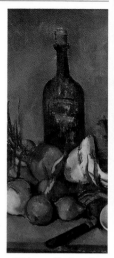

Cézanne liked to place objects with simple shapes, such as fruit or bottles, near drapery, which added suppleness and movement to a still life composition. Above and below: Details of *Still Life with Onions* (c. 1895). Left and bottom: Details of *Apples and Oranges* (c. 1895–1900).

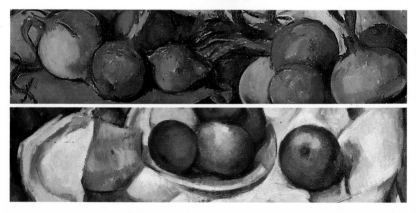

Certain Compositions, Such as *The Cardplayers,* Reached Their Final Form

The Cardplayers is one of Cézanne's most popular works. The subject had been a frequently painted one since the 17th century, and an early 17th-century painting by the Le Nain brothers on this theme is kept in the Musée Granet in Aix and thus almost certainly was seen

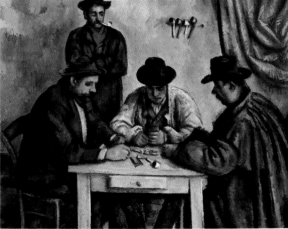

W hy did Cézanne decide to give so much attention to the theme of cardplayers at the same time he was painting a series of bathers? Perhaps because the cardplayers, with their concentrated appearance, facing each other in a closed space, are the direct antithesis of the bathers, with their impersonal silhouettes in an open-air setting. *The Cardplayers* (1890–2, above) in the Barnes Foundation in Philadelphia, one of the largest of Cézanne's compositions, gives a strong impression of concentration and tension. The much more serene *Cardplayers* (1890–2, left) is in the Metropolitan Museum of Art in New York. In this painting the confrontation is more restrained.

by Cézanne. There are five versions of *The Cardplayers,* plus some preparatory studies for isolated figures: one version with five characters, one with four, and three with two. There has been lengthy discussion on the order in which these five versions were painted. It seems that for stylistic reasons the three versions with two characters are later than the others where the composition is less concentrated and where the characters stand out against a light background. All the versions are based on a highly symmetrical arrangement; the central axis is marked in the earliest two by a person facing the spectator and in the other three by a bottle.

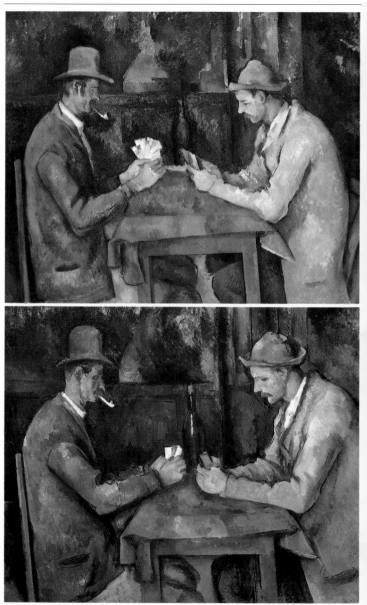

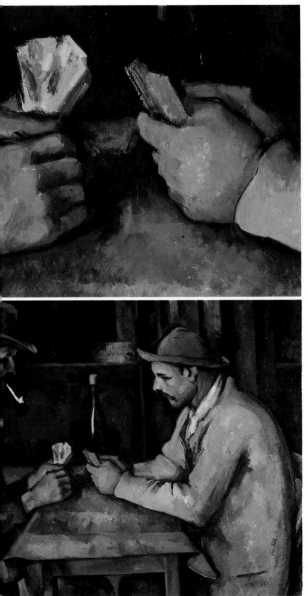

Did Cézanne in this series unconsciously express the struggles he had waged, not only with his father, but also with himself? The playing card has been thought to symbolize both a weapon and his work as a painter. In the art critics' vocabulary of the period, in one of Cézanne's own letters, and in discussions around the table at the Café Guerbois, the playing card was used to represent the simplified style and flattened drawing of Manet and the Impressionists. These three versions of *The Cardplayers*—two from 1890–5 (opposite above and below) and one from 1890–2 (left below and detail above)—reduce the composition to a duel between the two antagonists. They all express extreme tension between the two characters concentrating on their game. The setting has virtually entirely disappeared, the technique is very free, and the color is applied in determined brushstrokes.

At the Risk of Upsetting His Newfound Admirers, Cézanne Made a Completely Fresh Start in His Work

Oddly enough, he made this change at a time when his earlier works were beginning to be known and liked, at least by a small nucleus of admirers. His new technique was in no way a logical progression from his earlier work. It is, quite possibly, a unique case in the history of painting.

The subject matter is just as rich as ever—portraits, still lifes, landscapes, figures—but between 1890 and 1895 a radical change of style and treatment took place. Following serene arrangements of occupied space and voids, there came a succession of opaque compositions, after light and luminous tones, dark browns and blues.

From this point on, Cézanne totally abandoned traditional perspective and modeling with shade. At times, space simply ceases to exist; all the elements constituting the picture are placed on a single continuous plane without depth. This is the case with *The Forest* and *Women Bathers* canvases and with a few of the Mont Sainte-Victoire paintings. At other times Cézanne defines a new kind of spatial structure by an arrangement of planes at an oblique angle to the picture plane.

Once Again, It Is in Still Lifes That Cézanne's New Experiments Are Most Clearly Expressed

Now more sure of himself than he would admit in his letters, he began to choose quite large canvases, and his compositions became more complex. The simple forms and the polished surfaces of apples and crockery contrast

B elow: *Apples and Oranges* (c. 1895–1900, left) and *Still Life with Onions* (c. 1895, right). Opposite: *Still Life with a Plaster Cupid* (c. 1895).

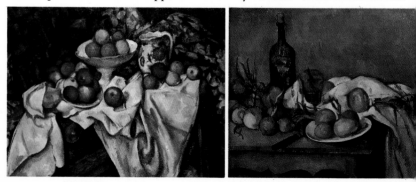

strongly with the moving, irregular folds of the drapery in both *Apples and Oranges* and *Still Life with Onions*. The description of objects and the arrangement of planes defy all the laws of painting to form a coherent world where each touch of color is determined by its place in the whole. Cézanne introduced a plaster statuette, a plump and dimpled 17th-century cupid—formerly attributed to Pierre Puget, but now believed to be by François Duquesnoy (1595–1643)—in the midst of the fruit and drapery in *Still Life with a Plaster Cupid.* The apples and the statuette are both evocative images with symbolic value: The chubby cherub clearly stands for health and youth. In striking contrast,

L ate in his life, Cézanne returned to using the dark colors of his youth. In his large watercolors, like *Skull on a Drapery* (left) of 1902–6, he played with the effects of transparency. He was able to maintain a freedom in the composition of his still lifes, never hesitating —contrary to common practice—to place objects out of balance.

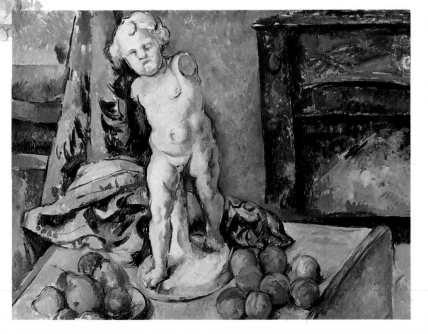

Cézanne also returned at the end of his life to the skull motif, which had disappeared from his work since the end of the 1860s.

Portraits and Individual Figures Both Underwent Drastic Simplification

Cézanne still painted just as many portraits of his wife. But he changed her pose and the setting, now making her sit in the open air or in a conservatory. Madame Cézanne appears distant and majestic, and usually she was placed purposefully by the painter in a rather constrained attitude and in indeterminate light.

There are portraits of others as well. By its emphasis on naturalness and by the importance given to the model's surroundings and profession, the painting of Gustave Geffroy of this period belongs to the tradition of humanist portraits. Geffroy was an art critic who was a good friend of Monet's, and the latter called his attention to Cézanne in 1894. Geffroy published two articles that were favorable to Cézanne when he was still virtually unknown. Cézanne painted his portrait in order to thank him. Eventually, the two men would have a falling out; Geffroy had not shown great understanding of either the painter's art or his personality.

Relations between Cézanne and Joachim Gasquet followed a similar course. This young poet from Aix, the son of one of Cézanne's childhood friends,

Art critic Geffroy thought Cézanne's 1895 portrait of him (below) one of the painter's finest works, in spite of its unfinished state: "The library, the papers on the table, the little plaster copy of a Rodin, the artificial rose he brought at the beginning of the sittings, all is outstanding work. Moreover, there is actually a person, too, in this setting, painted with scrupulous care and a richness of tones and a harmony that are incomparable."

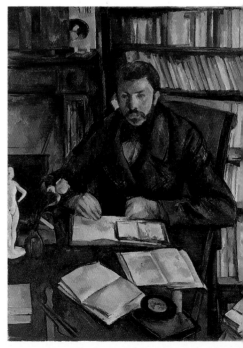

took a liking to him and became enthusiastic about the painter's work. Cézanne took him into his confidence for a time and in 1896 painted his portrait. Their relations would become strained because Gasquet was indiscreet and because Cézanne, touchy and unsociable, was always afraid of "falling into someone's clutches." Later Gasquet

In *Portrait of Joachim Gasquet* (1896, below) and *Man with Folded Arms* (c. 1899, opposite above) there are strong distortions of the planes.

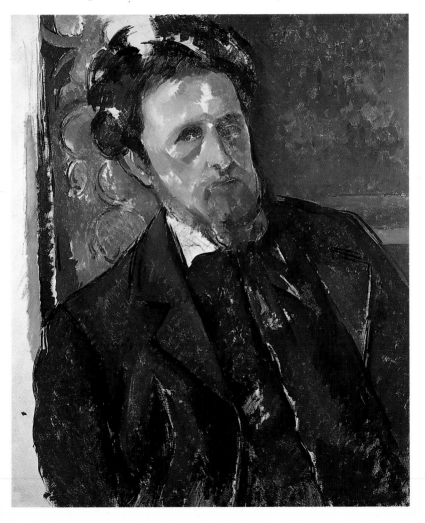

Images of encroaching vegetation are found in paintings by Gauguin, Monet, and Henri "le Douanier" Rousseau (1844–1910). They contrast strongly with the open panoramas and large skies of which Cézanne and the Impressionists had been fond during the 1870s. Left: *The Forest* (1895–1900).

published the transcript of his conversations with the artist, adding much of his own invention.

The death of Cézanne's mother in 1897 and subsequent sale of Jas de Bouffan meant that the artist had to seek a new living arrangement. (His wife and son remained in Paris.) It was during this period, when Cézanne was searching the neighborhood for his next home, that he painted several views of the Château Noir—a nearby property that he later tried to purchase—and Bibémus quarry.

In the Landscapes the Eye Encounters a Wall of Lush Vegetation Surrounding Gigantic Rocks

In the past Cézanne's landscapes had been organized around an open horizon and tiers of planes—a taste for a

wilderness without horizons, emptied of humanity, that was shared by Monet in his Waterlilies. In *The Forest* each brushstroke is posed with a watercolorist's lightness and sureness of hand, and there are very few corrections. Like Poussin, Cézanne changed his technique to differentiate between substances: The impasto is smooth for the rocks, broken up for the foliage, with at times a light trembling movement to suggest wind in the trees. In the outstanding *Lake Annecy*, the canvas becomes a wall of blue-toned ice. Few painters have known how to vary their medium to this extent.

Cézanne painted the Château Noir at least ten times, seen from above, below, and frontally in a plane parallel to that of the picture. He produced a striking effect

"Here I am, far from our Provence for a little.... This is a temperate zone. The height of the surrounding hills is quite considerable. The lake, constricted here by two gulleys, seems to lend itself to young misses' drawing exercises. It is certainly nature still, but a little like we have been taught to see it in young women travelers' albums of paintings."

Cézanne
letter to Joachim Gasquet
Annecy, July 1896

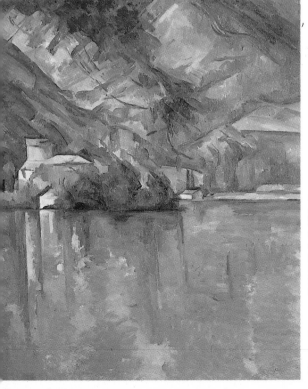

"I am doing some painting to stop being bored. It isn't very amusing, but the lake is very fine with big hills all around, they say two thousand meters, but it isn't a patch on our part of the world."

Cézanne
letter to Emile Solari
Annecy, July 1896

Left: *Lake Annecy* (1896).

Château Noir

"Situated halfway between Aix and the village of Le Tholonet, Château Noir had been built in the second half of the 19th century somewhat above the road near the bottom of the wooded hill that rises behind it. It consists of two separate buildings, set at a right angle to each other.... A series of pillars...rise into the sky, supporting nothing, and lend the complex an incongruous aspect of ruins. Incongruous, too, is the style of the buildings, with their narrow Gothic windows and steep roofs. Between them lies the court that Cézanne's room overlooked.... Even the name...'Château Noir' is a misnomer, for there is nothing black about it, nor is it a château; it is built of the beautiful yellow stone from the nearby Bibémus quarry.... In Cézanne's paintings it is always the glow of the orange-gold façade of the west wing, livened by the large red barn door...that dominates the unruly blue-green vegetation."

John Rewald
Cézanne: The Late Work
(exhibition catalogue)
1977

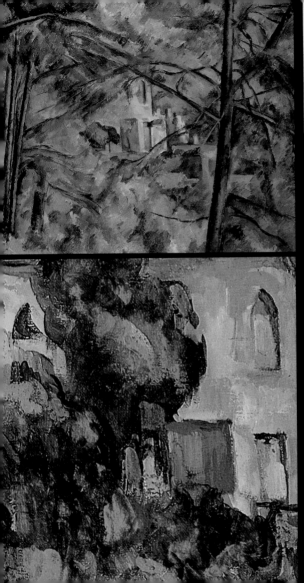

Green and Ochre Harmonies

"The sensations of color that provide the light cause abstractions that do not allow me to cover my canvas, nor to complete the limits of objects where their points of contact are fine and delicate; hence it follows that my image or picture is incomplete."

Cézanne
letter to Emile Bernard
23 October 1905

Above: *Pistachio Tree in the Courtyard of Château Noir* (c. 1900). Left: *Château Noir* (1894–6, above) and a detail of another *Château Noir* (1904–6, below). Opposite: *In the Park at Château Noir* (c. 1898).

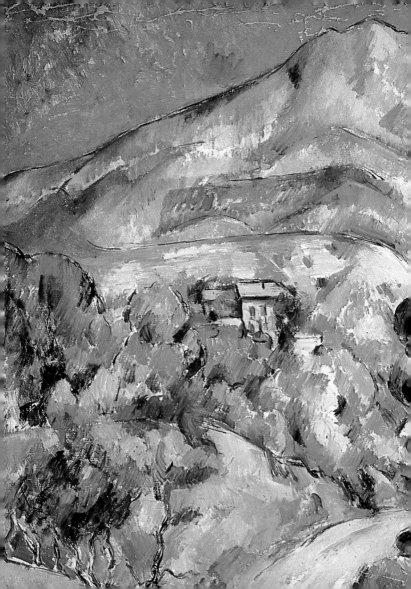

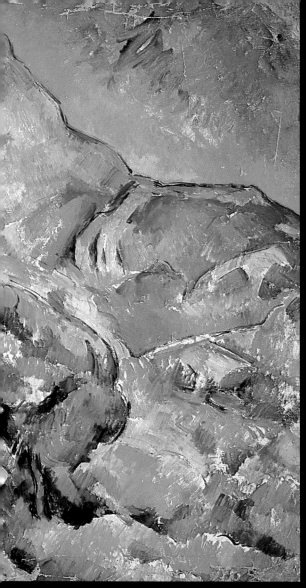

Mountain

In *Mont Sainte-Victoire Above the Road of Le Tholonet* (left and detail overleaf) of 1896–8, the mountain remains integrated within the panorama. There is no break, no rift between the plain and the low hills on the one hand and the mountain on the other. The colors are rendered simply but naturalistically in spirit: The sky is blue, the vegetation green, the earth light ochre, and the mountain pink-blue. The shift from one plane of color to another follows sinuous, irregular contour lines with few transitional spaces. Joachim Gasquet wrote about Cézanne finishing one of these Mont Sainte-Victoire paintings, "The canvas slowly acquired a sense of equilibrium. The preconceived image, well thought-out and linear, was already emerging from the patches of color defining it on all sides. The landscape seemed to flicker, for Cézanne had slowly worked around each object, taking samples, as it were, of each color; day by day, imperceptibly, he had brought together all these values into sure harmony, linking them together with a muted kind of clarity."

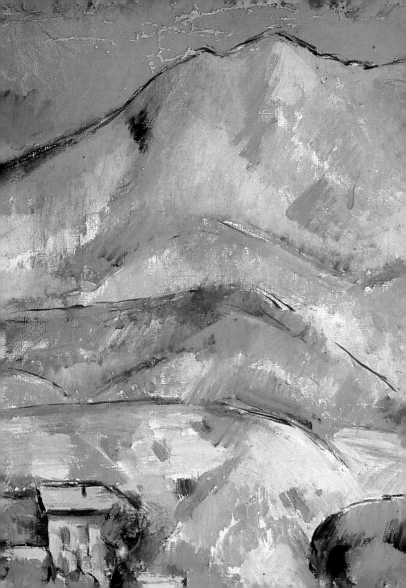

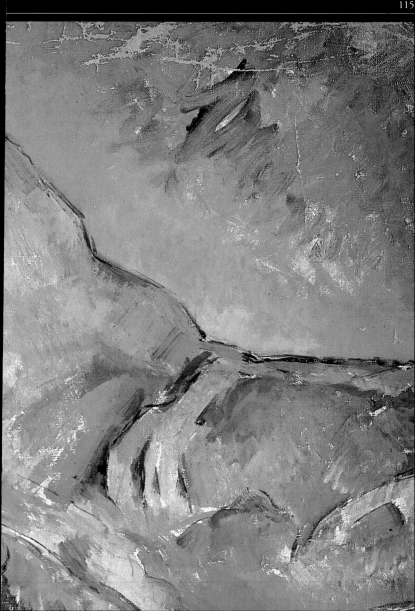

through the contrast of the ochre building and the streaks of the deep-green foliage against the sky.

Mont Sainte-Victoire continued to inspire him, but the viewpoints and the setting had changed. He often set up his easel on the road to Le Tholonet and painted it straight on.

"To Marry the Curves of Women to the Rumps of the Hills"

During his last years Cézanne set to work on an important canvas on the theme of women bathers. This subject had fascinated the painter for decades, but he had hitherto confined himself to quite small canvases. Around 1900, for the first time, he began to tackle pictures more than a yard wide. The largest version measured about seven feet by eight feet; it was the largest of Cézanne's paintings. He even had to have an opening made in the wall of his studio so that the canvas could be brought in without having to be rolled up.

Cézanne painted at least three large versions of the *Large Bathers*. The number and position of the figures vary markedly from one to another. Two frieze-like versions, which are striking and powerful and without parallel in the other canvases of the period, were worked on for a long time, put aside, and then undertaken again. It is thought that one was in the Paris studio and the other at Aix and that he worked alternately on one and then the other. The third, the largest, is composed as a superb Gothic arch, while the other two are more like bas-reliefs. The coloring

In 1904 Cézanne was photographed by Emile Bernard in his studio at Les Lauves in front of the *Large Bathers* (left) of 1900–5. This version belongs, in view of its frieze-like theatrical setting, to the extended series of Bathers pictures. It is part of the Barnes Foundation collection kept in Merion, Pennsylvania. Below: *Three Bathers* (1897–1900).

in the largest picture has the delicacy of a watercolor, with blue-gray the dominant color. Once more Cézanne had expressed ideal harmony in the satisfying union of the figures and the natural surroundings. Once more he is on a level with Poussin's most poetic humanist creations, in which he recognized a powerful lyricism held in check. A remark of Cézanne's about Poussin is often incorrectly quoted. He stated that he wished "to imbue Poussin with life by contact with nature" ("*vivifier Poussin sur nature*")—not "remake [*refaire*] Poussin according to nature"—that is, to embody the emotion he experienced in the

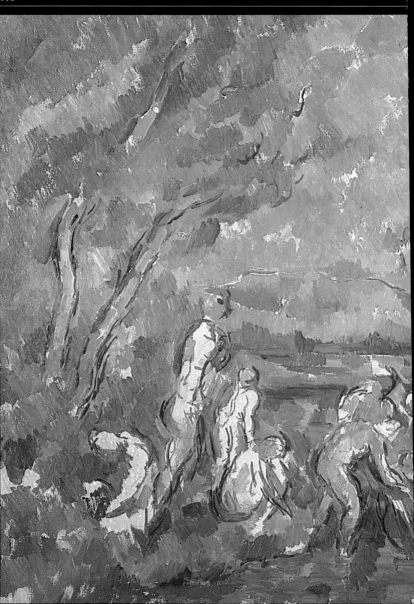

"Rather than a study fo[r] [the *Large Bathers* (1900–6)], this seems to be an independent version in which…the figures are no longer the primary focus, at least not as they appear in thi[s] unfinished work. But it i[s] 'unfinished' merely because there are spots o[f] canvas left uncovered; these occur in places where only colors—not compositional elements —are missing.… This loosely brushed picture i[s] completely dominated b[y] blue-gray tonalities with [a] few greenish-blue tints i[n] the ground, the trees an[d] the sky.… The darkest spot of the composition [is] a deep blue triangle in t[he] center foreground, around which four nude[s] are gathered. Their grou[p] is separated from those [at] the left and right in an arrangement not found elsewhere in Cézanne's work, except in a watercolor. Most of the bare white spaces are concentrated around th[e] groups of bathers on either side of this center[.] The figures of the centra[l] group appear to be bending down, as thoug[h] their attention were attracted by something on the ground."

John Rewa[ld]
Cézanne: The Late W[ork]
(exhibition catalog[ue])

19

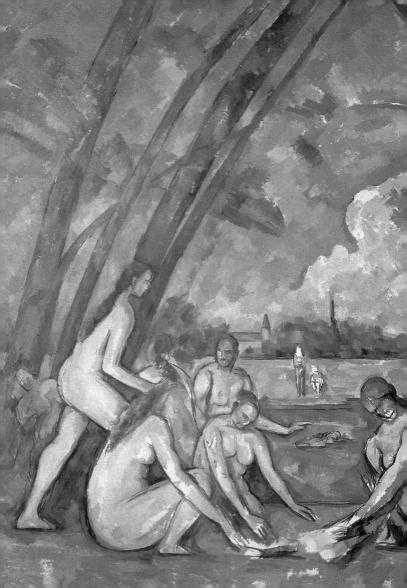

Large Bathers

"It is the largest of Cézanne's pictures and because it is also the most formal in aspect, it has been cited often as an example of his ideal of composition.… It is exceptional among his work, however, in the marked symmetry and the adaptation of the nude forms to the triangular pattern of the trees and river.… The atmosphere of this painting is strange and beautiful—the landscape is largely bluish, a soft haze in which sky and water and vegetation merge and by which the masterfully drawn figures are delicately overcast."

Meyer Schapiro
Paul Cézanne
1988

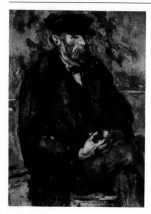

face of nature within the discipline of a Poussin landscape. He left us landscapes which have both grandeur and order, into which people fit harmoniously.

Cézanne's Last Works Display Freedom and a Visionary Quality

The *Old Woman with a Rosary* (1895–6) and the several different portraits of Cézanne's gardener, Vallier, have a compassionate side that had disappeared from the painter's world for over twenty years. Dark colors (Prussian blue, dark green, brown), thick impasto, and the tragic expression of the faces marked by age—all separate these moving figures from those of the preceding period.

He despaired of being able to render "this magnificent richness of coloring which animates nature." On 8 September 1906 he wrote to his son, "Here on the banks of the river there are so many subjects and the

The serious, pensive face of the *Boy with a Red Waistcoat* (below left, and detail right) of 1889–90 is one of the most expressive of Cézanne's works. The boy's sleeve, free from any figurative concern, is a prodigious feat of abstract art. Only the greatest painters have managed to combine such intense human feeling with such astonishing success in pure painting.

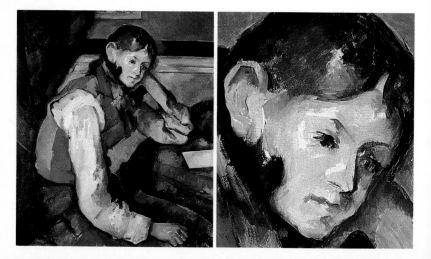

same one seen from a different angle makes a powerful and interesting study, so varied that I think I could be busy for months without moving from the spot and merely leaning sometimes more to the right, sometimes more to the left." His chosen subjects remained the forest and Mont Sainte-Victoire, to which he gave a new look after 1900.

The portraits of Vallier, Cézanne's gardener, in *The Sailor* (1902–6, opposite above) and *Seated Man* (1905–6, below) are semi-fantastic apparitions.

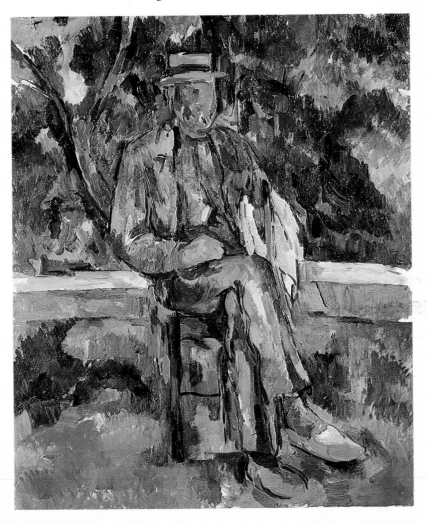

An Island, an Eruption, an Iceberg: The Last Mont Sainte-Victoires Have a New Identity

The colors are worked in an almost Impressionist manner, by the accumulation of small touches of paint, whether thinly or thickly applied. The part of the canvas that is usually called the ground, the earth, the vegetation, is totally indecipherable. With a few exceptions it is impossible to discern, as one could in the earlier versions, a house, a tree, an aqueduct. A clearly marked horizontal line separates the lower part of the surface—covered with dark greens, Prussian blues, and a little brown—from the mountain itself, which stands in isolation with its bluish, mauve, or dark green silhouette. The remainder of the upper part of the picture (where the sky can be seen) is a blend of a more sustained blue and green. This reading, however, is only the result of memory projecting the

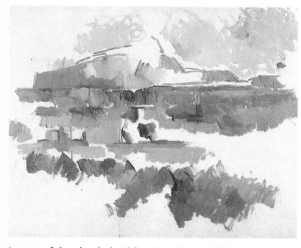

image of the clearly legible Mont Sainte-Victoire pictures of the preceding period onto the shape of the mountain and the sky.

In some of the Mont Sainte-Victoire paintings, in addition to several of the Château Noir and Bibémus quarry canvases, there are green patches that could not possibly, in any figurative rendering of reality, represent branches of trees. Here is a clear example of the arbitrary

In order to express the intense emotion he felt and mold it into harmonious form, Cézanne needed the incentive of working from nature. He wanted, he said, to transmit his sensations, but the pictures he painted are unreal and visionary, imbued with a powerful lyricism. (He was supposed, quite wrongly, to have defective eyesight.) In his last Mont Sainte-Victoire paintings, the mountain is no longer an integral part of the panorama of hills and vegetation, but a mass that is clearly distinguishable from them. It is no longer one element of a view, part of the same world as the plain, the trees, and houses; it is of a different nature. A very strongly defined horizontal line separates it from the rest of the landscape. Left: *Mont Sainte-Victoire Seen from Les Lauves* (1904–6). Opposite right, from top to bottom: Three views of Mont Sainte-Victoire (1904–6). Opposite below left: A photograph of Cézanne at his easel on the hill of Les Lauves taken in 1906 by painter Ker-Xavier Roussel.

placement of color, or rather, of a move away from representation of actual reality—even though visible reality was always the underlying foundation of Cézanne's works. Raoul Dufy, Fernand Leger (1881–1955), and many others have now made us familiar with modern art's interest in form and color, but Cézanne was the first to put his ideas into practice in a way that was shocking at the time.

A Subject Is Necessary

In a way it was this need to take the visible as his starting point that indirectly led to Cézanne's death. On 15 October 1906 a sudden and violent thunderstorm surprised him while he was painting. He lost consciousness and had to be carried home. Cézanne died of pneumonia a week later, on 23 October 1906.

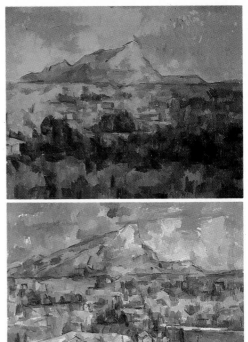

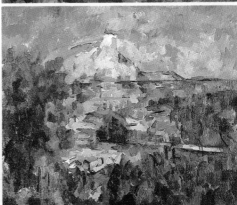

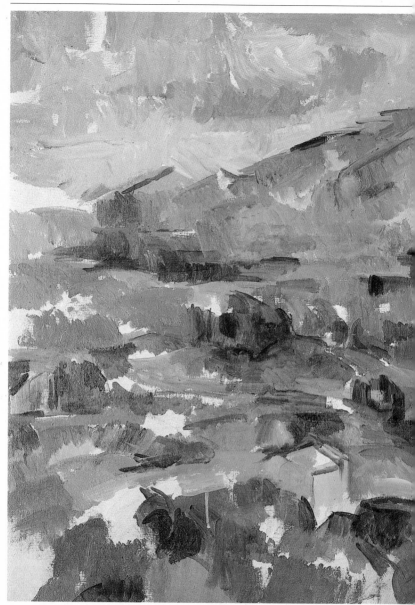

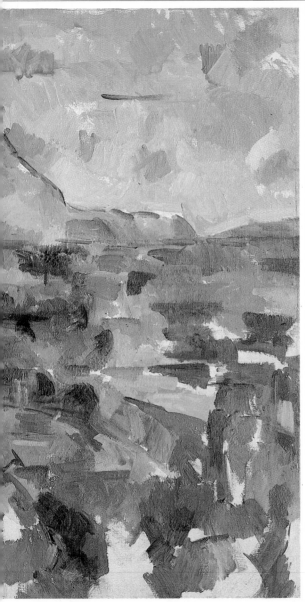

The First Modern Painter

"Cézanne is one of the greatest of those who changed the course of art history, and it is inappropriate to compare him to Van Gogh or Gauguin. He brings Rembrandt to mind. …[I]gnoring everything marginal and incidental, he has plumbed the depths of reality with the eye of wisdom, and if he himself has not arrived at those regions in which profound realism changes imperceptibly into luminous spirituality, at least he has left, for those who desire to attain it, a simple and wonderful method. He has taught us to master the vitality of the universe. He has revealed how inanimate, raw objects inflict change on one another. From him we have learned that to alter the coloring of an object is to alter its structure. His work proves without doubt that painting is not—or not any longer—the art of imitating an object by lines and colors, but of giving plastic form to our nature."

Albert Gleizes
and Jean Metzinger,
Du Cubisme, 1912

Left: *Mont Sainte-Victoire Seen from Les Lauves* (1902–6).

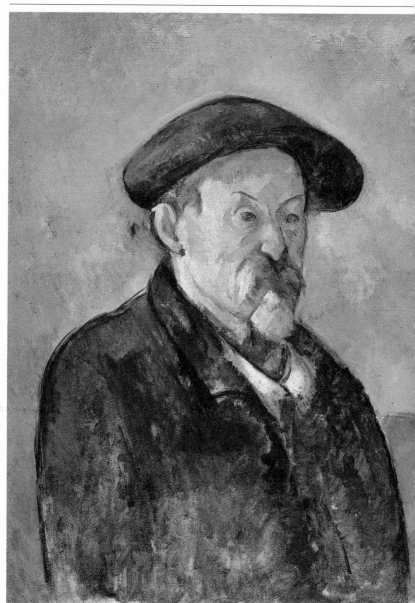

DOCUMENTS

Friendship Between Artists

It is through the writings of his most intimate associates, including Joachim Gasquet and Emile Zola, that we have gained a vivid impression of Cézanne the artist—his work, his ideas about art, and the effect he had on others.

Cézanne in around 1871.

Cézanne's Own Voice

Toward the end of his life Cézanne became acquainted with poet and novelist Joachim Gasquet (1873–1921), who later reconstructed and published their numerous conversations. According to Gasquet, it was difficult for Cézanne to explain in words what he was trying to do in paint.

All right,…look at this…. (He repeated his gesture, holding his hands apart, fingers spread wide, bringing them slowly, very slowly together again, then squeezing and contracting them until they were interlocked.) That's what one needs to achieve…. If one hand is too high, or too low, the whole thing is ruined. There mustn't be a single slack link, a single gap through which the emotion, the light, the truth can escape. I advance all of my canvas at one time, if you see what I mean. And in the same movement, with the same conviction, I approach all the scattered pieces…. Everything we look at disperses and vanishes, doesn't it? Nature is always the same, and yet its appearance is always changing. It is our business as artists to convey the thrill of nature's permanence along with the elements and the appearance of all its changes. Painting must give us the flavour of nature's eternity. Everything, you understand. So I join together nature's straying hands…. From all sides, here, there and everywhere, I select colours, tones and shades; I set them down, I bring them together…. They make lines. They become objects—rocks, trees—without my thinking about them. They take on volume, value. If, as I perceive them, these volumes and values correspond on my canvas to the planes and patches of colour that lie before me, that appear to my eyes, well then, my canvas "joins hands." It holds firm. It aims neither too

high nor too low. It's true, dense, full....
But if there is the slightest distraction,
the slightest hitch, above all if I interpret
too much one day, if I'm carried away
today by a theory which contradicts
yesterday's, if I think while I'm painting,
if I meddle, then whoosh!, everything
goes to pieces.

Joachim Gasquet
Cézanne, 1921
(Translated by Christopher Pemberton
as *Joachim Gasquet's Cézanne:
A Memoir with Conversations,* 1991)

The Camaraderie of Genius

*The roots of the friendship between the
painter Cézanne and the novelist Zola lay
in childhood, where dreams and desires are
born. Zola knew Cézanne perhaps better
than anyone, but he failed to appreciate the
artist and his work.*

LETTER TO CEZANNE

July 1860, Paris

You are an enigma to me, a sphinx, an
impossible and impenetrable mystery.
One of two things is true: Either you do
not want to, and you are achieving your
aim admirably; or you do want to, and in
that case I don't understand it at all.
Sometimes your letters give me hope,
sometimes they rob me of that and more,
like your last one, in which you almost
seem to say goodbye to your dreams,
which you could so easily convert into
reality. In this letter, there is this sentence
which I have tried in vain to understand:
"I am going to talk without saying
anything, for my conduct contradicts my
words." I have constructed many
hypotheses on the meaning of these
words, but none satisfies me. What,
then, is your behavior? That of a lazy
person no doubt. But what is surprising
about that? You are being forced to do
work that is distasteful to you, and you

Emile Zola.

want to ask your father to let you come
to Paris to become an artist. I do not see
any contradiction between this request
and your actions. You neglect your law
studies and go to the museum. Painting
is the only work you find acceptable.
There is, I think, an admirable unity
between your wishes and your actions.
Shall I tell you?—don't be angry. You
lack character; you have a horror of
exertion, whatever it may be, in thought
as well as in action; your main aim is to let
things take their course and to leave
yourself at the mercy of time and chance.
I do not say that you are completely
wrong; everyone sees things in his own
way or at least believes he does. Only you
have already followed this course in love.
You were waiting, you said, for the right
time and circumstances; you know better
than I, neither one nor the other has
arrived.... I thought it my duty to repeat
here for the last time what I have often
told you. As I am your friend, you must
excuse my frankness. In many respects,
our characters are similar; but, by Heaven!
if I were in your place, I would want to
have the last word, to risk all to gain all,
and not hesitate any longer between two
such different choices for my future,

between art and the law. I am sorry for you, for you must be suffering in this uncertainty, and this would be for me another incentive to tear the veil from your eyes. One thing or the other, be a lawyer or an artist, but do not remain a creature without a name, wearing a toga splashed with paint. You are a bit negligent—let me say this without making you angry—and my letters no doubt are lying about and your parents read them. I do not believe that I am giving you bad advice; I believe I speak as a friend and according to reason, but perhaps everyone does not see things as I do, and if what I have suggested above is true, I am probably not very well thought of by your family. For them, I am no doubt the *liaison dangereuse,* the stone thrown onto your path to trip you up. All this affects me deeply, but, as I have told you already, I have seen myself so often misjudged that one more wrong judgment added to the others would not surprise me. Remain my friend, that is all I desire.

Another passage of your letter grieved me. Sometimes, so you tell me, you throw your brushes at the ceiling when the results do not meet your ideas. Why this disheartened attitude, this impatience? I could understand this behavior if it took place after years of study, after thousands of useless attempts. Recognizing your incompetence, your inability to do well, you would then act wisely if you trampled your palette, your canvas, and your brushes underfoot.

But as, up to now, you have only had the wish to work, as you have not yet tackled the task seriously and regularly, you have no right to judge yourself incapable. So have courage. What you have done up to now is nothing. Have courage and remember that in order to arrive at your goal, you need years of study and perseverance. Am I not in the same position as you; is the form not just as rebellious under my fingers? We have the idea; so let us march freely and bravely on our path, and may God guide us!

Emile Zola

LETTER TO BAPTISTIN BAILLE

10 June 1861, Paris
I see Cézanne rarely. Alas! It is no longer as it was at Aix, when we were eighteen, free and without any worries about the future. Now the demands of our lives and our different work keep us apart.

In the morning Paul goes to the Atelier Suisse while I remain in my room to write. At eleven o'clock we have lunch, each of us on our own. Sometimes at midday I go to his place and he works on my portrait.

Then he spends the rest of the day drawing at [Joseph] Villevieille's; he has his supper, goes to bed early, and I do not see him any more.

Is that what I had hoped for? Paul is still the excellent, odd fellow whom I knew at school. To prove that he has lost none of his originality, I only have to tell you that hardly had he arrived here than he talked about returning to Aix; to have battled for three years for this trip and then not to care a straw!

Faced with such a character, with such unforeseen and such unreasonable changes of behavior, I admit that I do not say anything and suppress any logical thought. To prove something to Cézanne would be like trying to persuade the towers of Notre-Dame to dance a quadrille. He might say yes, but he would not budge an inch. And note that age has increased his stubbornness.... He is made of one single piece, obstinate and hard; nothing can bend him, nothing can wring a concession from him. He doesn't even

want to discuss his thoughts. He has a horror of discussion, first, because he finds talking tiring, and then because he would have to change his view of life if his adversary were right.

Emile Zola

LETTERS TO EMILE ZOLA

Cézanne often turned to Zola for financial help…

27 *August 1878, L'Estaque*

My dear Emile,

I appeal again this month to your kindness. I would be much obliged if you could once more send sixty francs to Hortense, who is at the Vieux Chemin de Rome 12 until 12 September .

I have not yet been able to find lodgings at Marseilles because I don't want them to be too expensive. I count on spending the whole winter there if my father agrees to give me money. In this way I could continue some studies I am making at L'Estaque, which I shall not leave until the last possible moment.

Thank you in advance and with my warmest greetings to you and your family.

Cézanne

…and he was frequently Zola's houseguest at Médan.

19 *July 1885, Vernon*

My dear Emile,

As you tell me, I shall come to Médan on Wednesday. I shall try to start in the morning. I should have liked to be able to go on with my painting, but I was in a great state of confusion, for, as I have to go down south, I decided that the sooner I went the better. On the other hand it would perhaps be better if I waited a little. I am in a state of indecision. Perhaps I shall get out of it.

I send you my cordial greetings.

Cézanne

L'Oeuvre

Zola could not understand Cézanne's paintings, nor those of the Impressionists. In 1886 the publication of Zola's novel L'Oeuvre *(excerpted below), in which Zola modeled a failed painter, Claude Lantier, on Cézanne, brought about a permanent break between the two friends.*

Such is the effort of creation that goes into the work of art! Such was the agonizing effort he had to make, the blood and tears it cost him to create living flesh to produce the breath of life! Everlastingly struggling with the Real

Zola's country residence, the Château de Médan.

and being repeatedly conquered like Jacob fighting with the Angel! He threw himself body and soul into the impossible task of putting all nature on one canvas and exhausted himself in the end by the relentless tension of his aching muscles without ever bringing forth the expected work of genius. The half-measures and trickery that satisfied other painters filled him with remorse and indignation; they were both weak and cowardly, he said. Consequently he was always starting afresh, spoiling the good in order to do better, because his painting "didn't say anything," finding fault with his women because, as his friends used to say, they didn't step out of the canvas and sleep with him! What was it he lacked, he wondered, to make them really alive? Next to nothing, probably. Some slight adjustment one way or the other. One day, overhearing the expression "near genius" applied to himself, he was both flattered and horrified. Yes, that must be the explanation, he thought, over-shooting or falling short of the mark through some maladjustment of the nerve centres, or through some hereditary flaw which, because of a gramme or two of substance too much or too little, instead of making him a great man was going to make him a madman. This was the notion he could never escape when despair drove him out of the studio, the notion of preordained impotence; he could feel it beating in his head with the persistence of a funeral knell … and his sympathy for Claude as a brother-artist had increased since he realized that Claude had somehow lost his foothold and, so far as his art was concerned, was slipping deeper and deeper into madness, heroic madness. At first he had been amazed, for he had had greater faith in his friend than in himself; ever since their schooldays he had considered himself inferior to Claude, whom he looked up to as one of the masters who would revolutionize the art of a whole epoch. Then his heart had been wrung by the spectacle of failing genius, and surprise had given way to bitter compassion for the unspeakable torments of impotence. Was it ever possible, in art, to say where madness lay? he wondered. Failures always moved him to tears and the more a book or a painting inclined towards aberration, the more grotesque and lamentable the artist's effort, the more he tended to radiate charity, the greater was his urge to put the stricken soul respectfully to sleep among all the wild extravagance of its dreams.

To end in this…
He recalled, too, how they had all worked together in later life, their certainty of victory, their insatiable hunger for success and the feeling that they could swallow Paris in one mouthful. How often, in those days, had he seen Claude as the great man, the man whose unbridled genius would leave the talents of all the rest of them far, far behind! He remembered "the mighty canvases" they dreamed of, the projects that were going to "shatter the Louvre," their untiring struggles, working ten hours a day, giving themselves body and soul to their art. And all to what purpose? After twenty years of passionate striving, this; this mean, sinister little object, universally ignored, isolated like a leper, a melancholy, heartbreaking sight! All the hopes, all the sufferings of a whole lifetime spent on the arduous task of bringing into the world what? This, this, this! Oh God!

Emile Zola
L'Oeuvre, 1886
(Translated by Thomas Walton as
The Masterpiece, 1950)

Cézanne and Zola at the turn of the century.

LETTER TO EMILE ZOLA

4 April 1886, Gardanne

My dear Emile,

I have just received *L'Oeuvre,* which you were good enough to send me. I thank the author of *Les Rougon-Macquart* for this kind token of remembrance and ask him to allow me to shake him by the hand in memory of years gone by.

Ever yours moved by the feeling of past times.

Cézanne

Confidences

In this transcription of a round of one of the Cézanne family's favorite games, the painter is shown to have confided feelings and ideas about friendship, nature, and painting that would be more fully developed later in his letters and conversations.

There was nothing in this studio near Aix to distract Cézanne from his sole preoccupation—painting.

The date of this particular game of Confidences is not known.

1. Q: What is your favourite colour?
 A: *General harmony.*

2. Q: What is your favourite smell?
 A: *The smell of the fields.*

3. Q: What is your favourite flower?
 A: *Scabiosa.*

4. Q: What animal is most appealing to you?
 A: (No reply)

5. Q: What colour eyes and hair do you prefer?
 A: (No reply)

6. Q: What do you consider the most estimable virtue?
 A: *Friendship.*

7. Q: What vice do you detest most?
 A: (No reply)

8. Q: What work do you prefer?
 A: *Painting.*

9. Q: What leisure activity do you enjoy most?
 A: *Swimming.*

10. Q: What seems to you the ideal of earthly happiness?
 A: *To have "une belle formule."*

11. Q: What seems the worst fate to you?
 A: *To be destitute.*

12. Q: May we ask how old you are?
 A: *(No reply)*

13. Q: What Christian name would you have taken if you had the choice?
 A: *My own.*

14. Q: What was the finest moment of your life?
 A: (No reply)

The studio at Les Lauves, built in 1901, was only a few minutes' walk from the foothills of Mont Sainte-Victoire.

15. Q: What was the most painful?
A: (No reply)

16. Q: What is your greatest aspiration?
A: *Certainty.*

17. Q: Do you believe in friendship?
A: *Yes.*

All these objects followed Cézanne from one studio to another.

18. Q: What moment of the day do you find most agreeable?
A: *The morning.*

19. Q: What historical personage are you most drawn to?
A: *Napoleon.*

20. Q: What character from literature or the theatre?
A: *Frenhoffer [sic].*

21. Q: In what region would you like to live?
A: *Provence and Paris.*

22. Q: What writer do you admire most?
A: *[Jean] Racine.*

23. Q: What painter?
A: *[Peter Paul] Rubens.*

24. Q: What musician?
A: *[Anton] Weber.*

25. Q: What motto would you take if you had to have one?
A: (No reply)

26. Q: What do you consider nature's masterpiece?
A: *Her infinite diversity.*

27. Q: Of what place have you retained the pleasantest memory?
A: *The hills of St Marc.*

28. Q: What is your favourite dish?
A: *Les pommes de terre à l'huile. [Cold potato salad]*

29. Q: Do you like a hard bed or a soft one?
A: *In-between.*

30. Q: To the people of which foreign country are you most drawn?
A: *To none.*

Autograph: Write one of your own thoughts or a quotation that you agree with.

Lord, you have made me strong and solitary.
Let me sleep the sleep of the earth.
[Alfred] de Vigny, [1797–1863]

Cézanne by Himself
Edited by Richard Kendall
1988

The Impressionist Encounter

Through his relationships with Pissarro and other painter friends, Cézanne learned to master his exaggerated Romanticism and discovered the world of color. But he very quickly drew away from the Impressionists and their "superficial" world. As early as 1874, he wrote to his mother, "I am beginning to think myself better than those around me."

Duranty Hails the "New Painting"

As far as colouring is concerned, [the Impressionists] have made a discovery of real originality, the sources of which cannot be found anywhere in the past, neither in the works of the Dutch school, nor in fresco painting, with its clear tones, nor in the light tonalities of the 18th century. They are not only concerned with that fine and subtle manipulation of colour which stems from the close and intimate observation of the most delicate tonal values which

Cézanne in a portrait etched by Camille Pissarro in 1874.

are contrary or complementary to each other. Their real discovery consists in the realization that a strong light *discolours* tones, that sunshine, reflected off objects, tends by virtue of its clarity to blend its seven prismatic rays into a single, uncoloured brilliance which is light. From one flash of intuition to another, they have succeeded in breaking up solar light into its rays, its elements, and to reconstruct it as a unity by the general harmony of the iridescence they spread on their canvases. From the viewpoint of the refinement of vision and the subtle penetration of colours, it produced an extraordinary result. The most astute physicist could find no fault with their analysis of colour…. You must realize that close to the hearts of all of them in this moment is a passion for a new approach and for freedom.

Louis-Emile-Edmond Duranty
La Nouvelle Peinture, 1876
(Quoted in *The Impressionists at First Hand,* edited by Bernard Denvir, 1987)

Strong Passions Mastered by the Structure of Color

It was because he never integrated or because he rejected the style of the artists he admired that Cézanne could show the strength of his originality from the beginning of his career. The slow process of absorbing the lessons of the masters inhibits young artists' means of expression in the first place. Only the present sanctification of art allows these clumsy attempts, where there is both pathos and rhetoric, to be taken as aesthetic successes.

In this respect, Cézanne's encounter with the Impressionists was to be crucial. He became a close friend of Pissarro. Being ten years older, this humble and generous man did not frighten Cézanne. But, even though he had known Pissarro

for several years, it was only in 1872 that he set up his easel by Pissarro's side. Pissarro and the Impressionists after him turned to open-air painting, observation of nature and had discovered a space no longer founded on geometry but structured by the play of light on the forms it fragmented. This influence allowed Cézanne to give up his research into the expression of the passions which was leading him nowhere. It channelled him towards observation of a subject in some ways nullified by the effort of understanding. By teaching him to be bound by his own sensations in the face of nature, Pissarro opened up a line of research he was to follow all his life. He became a model of freedom, forgetting what had happened before him and

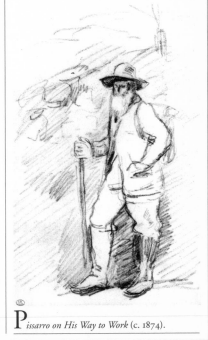

Pissarro on His Way to Work (c. 1874).

discovering his own personal method of representation. Pissarro liberated him from the obsession with form, an area where he was a failure, while his drawing was impelled by the strength of his passions.... Cézanne, who up until then had been a dilettante, said in 1871: "When I really understood Pissarro, I developed a passion for work." He summed up this lesson in this way: "I wanted to copy nature but did not succeed; but I was very pleased with myself when I discovered that it had to be represented through something else ... through color." Forms were no longer born of contours, color was to be the basis of representation, the object was to be reborn through the contrast of colors: "There is no such thing as line...there are only contrasts...of color."

An immediate effect to be noted was the blossoming of his senses due to the unfurling of his gifts as a superb colorist. The elimination of turbulent passions allowed his sensuality to blossom and luminosity and happiness replaced heavy, sombre tones. Violence, which led to furious and encrusted brushstrokes, made way for a patient working method that structured the canvas by the juxtaposition of small colored strokes.

Michel Artières
Menace d'Objet et Saisie du Motif
5 September 1984

Searching for the Structure of Things

Consequently, Cézanne studied effects of light and air and tried to convey them through color; he learned that objects have no specific color of their own, but reflect each other, and that air intervenes between eye and object. Cézanne not only made these observations on nature but also expressed them in his still lifes. The first of these, painted in Auvers, still reveal some of Manet's influence and are in somber tones: dull yellows and reds against absolutely black backgrounds. Cézanne painted them in Dr. Gachet's studio and chose as subjects glasses, bottles, knives, and other not very colorful objects.... But Cézanne soon tired of the limited range of whitish browns and the grays that predominate in these compositions and began to paint the flowers that Madame Gachet picked for him in her garden. These little canvases have remarkably clear and vibrant colors: blues, reds, and yellows of extraordinary intensity that bear witness to the pleasure he felt in rendering such richness of tone....

As Cézanne developed his art, he detached himself increasingly from the Impressionist conceptions. He did not seek to capture the impression and vibrant atmosphere of a landscape but rather to portray its forms and colors, its planes and light. He did not approve of Monet's attempts to render the same subject at different times of the day, to show the different shapes and tints produced by the varying intensity of the sun. Nor did he approve of the efforts of "the humble and colossal" Pissarro, as he called him admiringly, who was then being attracted by the Divisionism of Georges Seurat and painting his pictures in the pointillist technique.... As for Renoir, Cézanne did not like his landscape technique, which he called "cottony." Altogether he had the impression that his friends experimented too much, that they did not look behind the colorful exterior for the actual structure of things; it is doubtless for this reason that he assumed the task of "making out of Impressionism something solid and durable like the art of museums."

John Rewald
Cézanne: A Biography, 1986

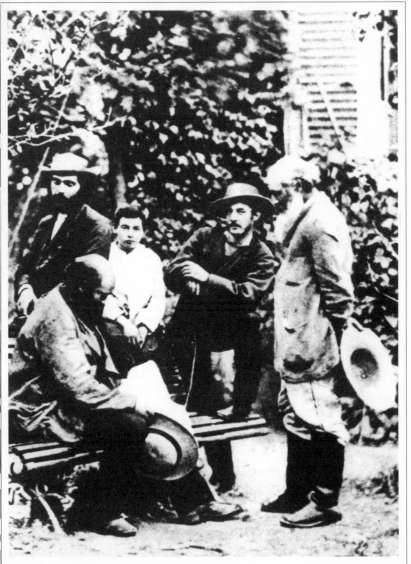

Cézanne (seated left) in the garden of the master Impressionist Camille Pissarro (standing right) at Pontoise in 1877.

Cézanne on Painting

Cézanne chose to withdraw from public life very early on in his career. He lived like a hermit and had only one master and model: nature. The reasons for this choice can be found in his letters.

A facsimile of Cézanne's letter to Count de Nieuwerkerke.

Cézanne wanted his work to be judged by the public and not by the juries and critics of the official Salon, whom he despised.

TO COUNT DE NIEUWERKERKE,
DIRECTOR OF FINE ARTS

19 April 1866
2 Rue Beautreillis, Paris

Dear Sir,

I recently had the honor of writing to you about two paintings of mine which the jury of the Salon turned down.

As you have not answered me, I feel I must remain firm about the motives that led me to address you. Moreover, as you have certainly received my letter, there is no need for me to repeat the arguments that I thought necessary to submit to you. I content myself with saying again that I cannot accept the unjustified criticism of fellow artists whom I have not myself expressly asked to appraise me.

I am therefore writing to you to insist on my request. I wish to appeal to the public and show pictures in spite of their being rejected. My desire does not seem to me to be extravagant, and if you were to ask all the painters in my position, they would reply without exception that they disown the jury and that they wish to take part in one way or another in an exhibition that should as a matter of course be open to every serious worker.

Therefore let the Salon des Refusés be reestablished. Even were I to be there alone, I should still ardently wish that people should at least know that I no more want to be mixed up with those gentlemen of the jury than they seem to want to be mixed up with me.

I trust, Monsieur, that you will not continue to keep silent. It seems to me that every decent letter deserves a reply.

I beg to remain, Sir, yours very faithfully.

Cézanne

TO OCTAVE MAUS (1856–1919), BELGIAN
ART CRITIC AND CURATOR

27 November 1889, Paris

Dear Sir,

Having learned the contents of your
flattering letter, I should like to thank
you first and then accept your kind
invitation with pleasure.

May I, however, be permitted to
refute the accusation of disdain which
you attribute to me with reference to my
refusal to take part in exhibitions
of painting?

I must tell you with regard to this
matter that, as the many studies to
which I have dedicated myself have
given only negative results, and as I am
afraid of only too justified criticism, I
had resolved to work in silence until the
day when I should feel myself able to
defend theoretically the result of my
attempts.

However, in view of the pleasure in
finding myself in such good company, I
do not hesitate to alter my resolve and I
beg you, Monsieur, to accept my thanks
and good wishes.

Cézanne

TO JOACHIM GASQUET (1873–1921),
POET AND NOVELIST

30 April 1896, Aix

But I curse the Geffroys and the few
characters who, for the sake of writing
an article for 50 francs, have drawn the
attention of the public to me. All my life
I have worked to be able to earn my
living, but I thought that I could do
good painting without attracting
attention to my private life. Certainly, an
artist wishes to raise himself
intellectually as much as possible, but
the man himself must remain obscure.
The pleasure must be found in the work.

If it had been given to me to realize

my aim, I should have remained in my
corner with the few studio companions
with whom we used to go out for a
drink. I still have a good friend
[probably Achille Emperaire] from that
time. Well, he has not been successful, a
fact which does not prevent him from
being a bloody sight better painter than
all the daubers, with the medals and
decorations which make one sick; and
you want me at my age to believe in
anything?

Cézanne

*Joachim Gasquet recorded Cézanne's
musings while the artist painted a portrait
of Gasquet's father, Henri.*

Ah, everyone knows his own troubles....
As far as I'm concerned I know you
because I'm painting you.... I tell you,
Henri, what you have is certainty. That's
my great ambition. To be sure! Every
time I attack a canvas I feel convinced,
I believe that something's going to come
of it.... But I immediately remember
that I've always failed before. Then I
taste blood....

Now take you, for instance, you
know what's good and what's bad in life,
and you follow your own path.... But
me—I never know where I'm going
or where I want to go with this damned
profession. All the theories mess you
up inside.... Is it because I'm timid in
life? Basically, if you have character you
have talent.... I don't mean to say that
character is enough, that it's enough
to be a good fellow in order to paint
well.... That would make it too easy....
But I don't believe that a scoundrel can
have genius.

Joachim Gasquet
Cézanne, 1921
(Translated by Christopher Pemberton
as *Joachim Gasquet's Cézanne:
A Memoir with Conversations*, 1991)

TO A YOUNG ARTIST

c. 1896

I have perhaps come too early. I was the painter of your generation more than of my own.... You are young, you have vitality; you will impart to your art an impetus which only those who have emotion can give. As for myself, I feel I am getting old.... Let's work!...
Perception of the model and its realization are sometimes very long in coming.

Cézanne

TO CHARLES CAMOIN (B. 1879), PAINTER

13 September 1903, Aix

[Thomas] Couture used to say to his pupils: "Keep good company, that is: Go to the Louvre. But after having seen the great masters who repose there, we must hurry out and, by contact with nature, revive within ourselves the instincts, the artistic sensations that live within us."

Cézanne

TO EMILE BERNARD (1868–1941)

15 April 1904, Aix

May I repeat what I told you here: See in nature the cylinder, the sphere, the cone, putting everything in proper perspective, so that each side of an object or a plane is directed toward a central point. Lines parallel to the horizon give breadth, that is, a section of nature, or, if you prefer, of the spectacle which the *pater omnipotens aeterne deus* spreads before our eyes. Lines perpendicular to this horizon give depth. But nature, for us men, is more depth than surface, whence the necessity of introducing in our vibrations of light—represented by reds and yellows—a sufficient quantity of blue to give the feeling of air.

Cézanne

12 May 1904, Aix

I proceed very slowly, for nature reveals herself to me in very complex ways and there is endless progress to be made.

The Musée Granet at Aix-en-Provence.

One must look at the model and feel very exactly; and also express oneself distinctly and with force. Taste is the best judge. It is rare. Art addresses itself only to a very limited number of individuals.

The artist must scorn all judgment that is not based on intelligent observation of character. He must beware of the literary spirit which so often causes the painter to deviate from his true path—the concrete study of nature—to lose himself too long in intangible speculation.

The Louvre is a good book to consult but it must be only an intermediary. The real and great study to be undertaken is the manifold picture of nature.

Cézanne

TO HIS SON

8 September 1906, Aix

Finally, I must tell you that as a painter I am becoming more clear-sighted

before nature, but that I always find the realization of my sensations painful. I cannot attain the intensity that is unfolded before my senses. I do not have the magnificent richness of coloring that animates nature. Here on the banks of the river there are so many subjects and the same one seen from a different angle makes a powerful and interesting study, so varied that I think I could be busy for months without moving from the spot and merely leaning sometimes more to the right, sometimes more to the left. I believe the young painters to be much more intelligent than the rest, the old painters can only see a disastrous rival in me.

Cézanne

26 September 1906, Aix

[Charles] Camoin showed me a photograph of a figure by the unfortunate Emile Bernard; we are all agreed on this point, that he is an intellectual saturated with memories from museums, but who does not look enough at nature, and that is the great thing, to make himself free from the school and indeed all schools. So that Pissarro was not mistaken, though he went a little far, when he said that all the necropolises of art should be burned down.

Certainly one could make a strange menagerie with all the professionals of art and their kindred spirits.

Cézanne

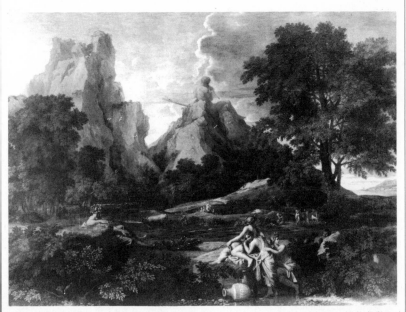

In *Polyphemus* (1649), a painting by Nicolas Poussin, the mountain dominates the scene but does not completely overpower the people.

Views of the Critics

"Crude experiments…,"
"Disgusting filth…,"
"Impulsive, meaningless art…,"
"Crazy as a savage…,"
"A hopeless failure…." While many painters recognized and admired Cézanne, the critics—with few exceptions—hardly spared him, even after his death.

The *Strangled Woman* (c. 1870–2) displays the theatrical composition of *A Modern Olympia* (c. 1873) that so appalled the critics at the first Impressionist exhibition in 1874.

The First Impressionist Exhibition, Paris, 1874

Shall we talk of M. Cézanne? Of all known juries, not one has ever imagined, even in dreams, the possibility of accepting any work by this painter who came to the Salon carrying his canvases on his back like Jesus carried his cross. A too consuming love of yellow has up to now compromised M. Cézanne's future.

Ernest d'Hervilly
Le Rappel, 17 April 1874

Suddenly he gave a great cry when he saw *The House of the Hanged Man* by M. Paul Cézanne. The stupendous thick fleshy impasto of this little jewel completed the work begun with the *Boulevard des Capucines;* old father Vincent would be delirious….

"Don't talk to me about *A Modern Olympia,* there's a good fellow!

"Alas! just go and see that one. There is a woman bent in two with a black woman lifting the last veil to present her in all her ugliness to a brown puppet. Do you remember the *Olympia* of M. Manet? Well, that was a masterpiece of drawing, accuracy, compared to the one by M. Cézanne."

At last the vessel overflowed. The classical mind of old father Vincent, attacked from too many sides at once, became completely unhinged. He stopped in front of the Parisian keeper of all these treasures and, taking him for a portrait, began to criticize him in a very pronounced way.

"Is he ugly enough?" he said shrugging his shoulders. "From the front he has two eyes…and a nose…and a mouth!… The Impressionists wouldn't have bothered with all that detail. With all that time and energy wasted on useless things, Monet could have painted

twenty Parisian keepers!"

"Keep moving there, you," the "portrait" said to him.

"Just listen to that! He can even speak! That must have taken the beggar who daubed him some time to do!"

Louis Leroy
"The Exhibition of the Impressionists"
Le Charivari, 25 April 1874

The Third Impressionist Exhibition, Paris, 1877

The artist who has been the most attacked, the most badly treated by the press and public for the past fifteen years, is M. Cézanne. There is no scurrilous epithet that has not been coupled with his name, and his works have the success of a howling farce, and continue to do so.... In his works, M. Cézanne is a Greek of the golden age; his canvases have the calm and heroic serenity of the paintings and terra-cottas of antiquity, and the ignorant people who laugh at *The Bathers,* for example, make me think of barbarians criticizing the Parthenon.

M. Cézanne is a painter and a great painter. Those who have never wielded a paintbrush or a pencil have said he did not know how to draw and they have reproached him for imperfections which are in fact subtle refinements achieved through enormous skill.

I know that, in spite of all, M. Cézanne cannot achieve the success of painters in fashion.... However, M. Cézanne's painting has the unutterable charm of biblical and Greek antiquity, the movements of people are simple and great as in antique sculpture, the landscapes possess compelling majesty, and his still lifes, which are so beautiful and so exact in their harmony of tones, have a solemn quality of truth. In all his paintings, the artist moves us, because he himself experiences, by observing

nature, a violent emotion which his craftsmanship transmits to the canvas.

Georges Rivière
L'Impressioniste, 14 April 1877

The Salon d'Automne, Paris, 1904

What at first sight singles out M. Cézanne's painting is clumsy drawing and heavy colors. His still lifes, which have been much praised, are coarsely rendered and lifeless. It has been predicted that they will one day go to the Louvre and keep company with Chardin. This happy time is not imminent.

M. Fouquier
Le Journal, 14 October 1904

Ah! Cézanne! Blessed are the poor in spirit, for the heaven of art is theirs! But truly, corrupt as we are, why compose, draw, and paint? Why seek to know when it is so voluptuous to feel? Why speak of education, instruction, erudition, since art is immediate, impulsive, meaningless, and mad as a hatter?

M. Bouyer
La Revue Bleue, 5 November 1904

I see that the Cézannes have had a great success at the Salon d'Automne—it was about time!

Mary Cassatt
Letter to Théodore Duret
30 November 1904

The Salon d'Automne, Paris, 1905

What do they still want with M. Paul Cézanne? Is his cause really not listened to? Doesn't everyone who has seen his works consider him a complete failure? Too bad for the dealers who thought, because of Zola's belief, that there would be a good deal to be made from his works. M. Vollard should come to a decision!

Camille Mauclair
La Lanterne, 19 October 1905

As for M. Cézanne, his name will remain linked to the most memorable joke in art for these last fifteen years. It has taken all the "Cockney impudence" of which Ruskin speaks, to invent the "genius" of this honest old man who paints for pleasure in the provinces and produces heavy works, which are badly constructed though some conscientiously at times. He also produces still lifes of moderately beautiful subjects and rather crude coloring, landscapes of lead, and figures which a journalist recently called "like Michelangelo's" but which are quite simply the shapeless experiments of a man who has not been able to substitute good will for know-how.

Camille Mauclair
La Revue, 15 December 1905

The Salon d'Automne, Paris, 1906: Cézanne Retrospective

To deny that Cézanne is one of the most conscious, one of the most serious and one of the most individual masters of today is to deny the evidence. To treat him as a "clever mason," as a quaint, wild drawer of pictures, who "sees crooked" in front of nature, is not tenable any longer. The joke has really lasted too long. Just the same, who the devil would dream of denying his faults: uneven, stumbling, clumsy, shapes that are warped, backgrounds that move forward, planes that are turned upside down, lopsided characters. We know all that. But does Rubens have taste, and Renoir ideas?

Louis Vauxcelles
Gil Blas, 5 October 1906

Grafton Galleries, London, 1905

"Hullo! What's this? What are these funny brown-and-olive landscapes doing in an Impressionist exhibition? Brown! I ask you? Isn't it absurd for a man to go on using brown and call himself an Impressionist painter? Who are they by? Oh, Cézanne. That's the man who paints still life. Now, I like those better. Those apples over there are really very good. And this other thing, *Dessert.* That's not so bad. The apple's quite good, isn't it? and the knife. But that right-hand side of the flask is pretty wobbly, and that glass hasn't quite come off. He's not very strong on drawing, is he? But I like his draperies, that curtain, and the table-cloth; and the table too, that's really quite good. Yes, there's something in it, but it's rather dark and brown. I don't like his color. Let's go back and look at the Monets."

That is how the "fans" of Impressionist painting talked about Cézanne in 1905.

Frank Rutter
Art in My Time, 1933

Grafton Galleries, London, 1910

To the Grafton Gallery to look at what are called the Post-Impressionist pictures sent over from Paris. The exhibition is either an extremely bad joke or a swindle. I am inclined to think the latter, for there is no trace of humour in it. Still less is there a trace of sense or skill or taste, good or bad, or art or cleverness. Nothing but that gross puerility which scrawls indecencies on the walls of a privy. The drawing is on the level of that of an untaught child of seven or eight years old, the sense of colour that of a teatray painter, the method that of a schoolboy who wipes his fingers on a slate after spitting on them. There is nothing at all more humorous than that, at all more clever. In all the 300 or 400 pictures there was not one worthy of attention even by its singularity, or appealing to any feeling but of disgust.

Wilfrid Scawen Blunt
diary entry for 15 November 1910
My Diaries, 1920

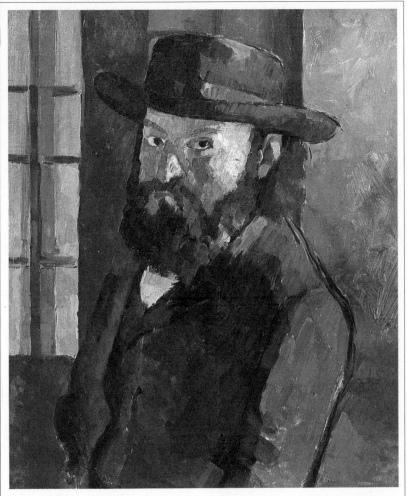

"He was a large and handsome fellow with long, dark-brown hair and a beard of the same color, which was naturally curly. His slightly aquiline nose and his big black eyes resulted in giving him a certain resemblance to the characters in the Assyrian bas-reliefs in the Louvre. He did not look like this for long. A few years later, he was bald on top, his beard and hair were cut shorter and were already sprinkled with gray hairs, but his eyes had kept their brilliance. In his last years, his appearance had changed again. Those who knew him in the last phase of his life are in agreement in describing him as an old retired officer."

Georges Rivière, *Le Maître Paul Cézanne*, 1923

Homage and Heritage

Cézanne is one of the few artists to gather as many judgments and tributes from the greatest painters among his contemporaries as from the greatest of his successors. Cézanne, the solitary artist, changed the course of art history.

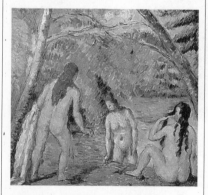

T*hree Bathers* (1879–82), a painting bought by Matisse in 1889.

Tributes to Cezanne from His Contemporaries...

Cézanne's effect upon his contemporaries is already apparent in certain early works by Pissarro, his chosen mentor. But the first major figure of his generation to benefit significantly from it was Gauguin, one of the earliest collectors of Cézanne's pictures, among them the *Still-life with Compotier,* which Gauguin valued above all other works in his collection. This admiration led him, in 1890, to paint a portrait of an unknown woman [see p. 52b] seated in a pose familiar from Cézanne's portraits of his wife of the 1880s, against a background featuring the *Compotier* still-life.

In further homage to the elder master, Gauguin adopts Cézanne's parallel, "constructive" brushwork in this picture, though he simplifies the colour modulations in the *Still-life* in keeping with the more two-dimensional concerns of his own style. He thus drew attention to the decorative features of Cézanne's art, which were soon to make him one of the spiritual leaders of the Symbolist painters of the 1890s who had initially found inspiration in Gauguin.

Included among these were Emile Bernard and Maurice Denis, the latter of whom acknowledged Cézanne's importance for the group in his *Homage to Cézanne.* Exhibited in Paris in 1901, this shows a gathering of Cézanne's admirers and disciples—including Redon, Bonnard, Vuillard, and Sérusier, in addition to Denis—around the *Still-life with Compotier.* The result is a homage to Cézanne comparable to the latter's *Apotheosis of Delacroix.* Deeply touched by this tribute from the younger generation, Cézanne wrote to Denis expressing his gratitude in June 1901. "Perhaps this will give you some idea of

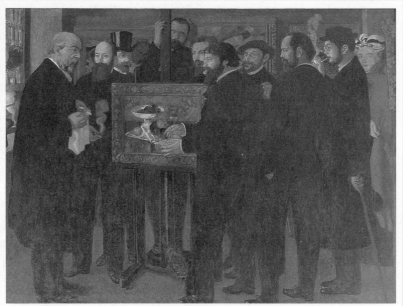

Gathered around a still life that once belonged to Gauguin are painters Odilon Redon and Edouard Vuillard; critic André Mellerio; art dealer Ambroise Vollard; painters Maurice Denis, Paul Sérusier, Paul-Elié Ranson, Ker-Xavier Roussel, and Pierre Bonnard; and Denis's wife. All pay homage to Cézanne in Denis's painting of 1900.

the position as a painter which you occupy in our time," replied Denis, "of the admiration which you evoke and of the enlightened enthusiasm of a group of young people to which I belong and who can rightly call themselves your pupils, as they owe to you everything which they know about painting."

When Denis wrote, Cézanne's canvases still remained relatively inaccessible to a wide public. With the major showings of his works which took place in Paris in 1904–6, however, his crucial importance for artists of the younger generation became increasingly apparent. This was confirmed by the two memorial exhibitions devoted to the artist in 1907, the year after his death,

when 79 watercolours were exhibited at [the Gallery] Bernheim Jeune in June and 56 oils and watercolours at the Salon d'Automne in October. (It was the latter of these exhibitions that made such a profound impression upon [German poet Rainer Maria] Rilke.)

Even before these commemorative events, Cézanne had attracted the attention of three of the pioneers of early 20th-century art, Matisse, Picasso, and Braque. Unlike their Symbolist predecessors, who were principally drawn to the decorative elements in Cézanne's style, these masters were instead attracted to its most architectonic features.

For Matisse, who purchased Cézanne's [Three] Bathers in 1899, Cézanne became

a model of order and clarity in painting, whose example spurred him to explore effects of solidity and relief in his own art in the years around 1900....

Though other artists of his time drew more far-reaching conclusions from Cézanne's art, Matisse alone maintained a lifelong interest in it which was truly comprehensive and deserves to be seen as Cézanne's rightful heir. For not only did he choose to follow his great predecessor in working directly from nature but he remained aware of the equal importance which Cézanne had accorded to both form and colour in building up the armature of a picture.

But it was left for the creators of Cubism, Picasso and Braque, to investigate the most radical implications of Cézanne's style—its analytical approach to form and its rhythmic accentuation of the entire picture surface through a series of interpenetrating shapes and colours which generate space while also stressing the autonomy of the picture plane....

Cézanne himself had anticipated this development when he referred to his own painting as "the logical development of everything we see"— implying by this a mental alteration of a visual sensation done in the interests of the compositional structure of a picture. In his art, however, this still took place before a motif in nature and was intended to reveal an invisible truth about it.

But in the art of his Cubist followers it came increasingly to be done without any reference to the visible world, thus severing that link with perceived reality that had united artists from Giotto to Cézanne and paving the way for the conceptual art of our own age.

Richard Verdi
Cézanne, 1992

Paul Gauguin (1848–1903)

Although ostensibly describing Cézanne, Gauguin was in fact describing himself; one has only to replace Virgil with Maori legends.

LETTER TO EMILE SCHUFFENECKER

14 January 1885, Copenhagen
Look at Cézanne the Misunderstood: an essentially mystical, oriental temperament (his face looks like an old man from the Levant). He is partial to forms that exude the mystery and the tranquillity of a man lying down to dream. His sombre colors are in keeping with the oriental frame of mind. A man of the Midi, he spends entire days on mountaintops reading Virgil and gazing at the sky. Thus his horizons are very high, his blues very intense, his reds stunningly vibrant.

Like Virgil, who has more than one meaning and can be interpreted as you like, the literature of his paintings has a parabolic, twofold meaning. His back-grounds are as imaginative as they are real.

Paul Gauguin

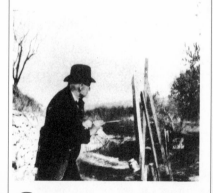

Cézanne in 1906.

Claude Monet (1840–1926)

LETTER TO GUSTAVE GEFFROY

23 November 1894, Giverny

It's agreed for Wednesday.*

I hope Cézanne will still be here and that he will join the party, but he is so odd, so fearful of seeing new faces that I am afraid he may be absent in spite of his earnest wish to get to know you. What a shame this man has not had more support in his life! He is a real artist but one who has doubted himself far too much. He needs cheering up, that's why he appreciated your article so much!

Claude Monet

Monet had invited Geffroy to Giverny to meet Cézanne at a luncheon on 28 November 1894.

Camille Pissarro (1830–1903)

LETTERS TO HIS SON, LUCIEN

21 November 1895, Paris

I was also thinking of Cézanne's show, in which there are some exquisite things, some still lifes of irreproachable perfection, others much worked on and yet left unfinished, and, even more beautiful than the rest, some landscapes, some nudes, some unfinished heads which are, however, truly imposing and so artistic, so supple.... Why?? Because sensation is there.

4 December 1895, Paris

Can you believe it, Heymann has had the cheek to start the absurd rumor that Cézanne was influenced all the time by [Armand] Guillaumin? We just have to hope the public won't be taken in by it! It's the limit, and it all happened at Vollard's. Vollard was flabbergasted. Bah! Let sheep piss, as they say in Montfoucault. Isn't all this gossip amusing?

You have no idea how hard it is to make some patrons and friends of the Impressionists understand how many great and rare qualities there are in Cézanne. I believe centuries will pass before they realize it. Degas and Renoir are in raptures about Cézanne's works. Vollard showed me a drawing of some fruit. They tossed a coin to know who would be the happy owner.

Degas is passionate about Cézanne's drawings, what do you think about that? Didn't I take a correct view of things in 1861, when [Francesco] Oller and I went to see this peculiar Provençal in the Atelier Suisse where Cézanne was painting some studies from the nude. He was the butt of all those impotent men of the school, among them that notorious [Maurice] Jacquet, wallowing in the pretty-pretty for many a year, whose works were being paid for in gold!!

It's very amusing, this reawakening of old battles!

...And from His Heirs

Paul Signac (1863–1935), Neo-impressionist Painter and Theorist

Cézanne's brushstroke is the line that unites the Impressionists' method of execution with the Neo-impressionists'. The principle—held in common but applied differently—of a mixture of points of view links these three generations of colorists who all pursue light, color, and harmony by similar techniques.

D'Eugene Delacroix au Néo-Impressionisme, 1899

Paul Sérusier (1865–1927), Founder of the Nabis Group

Cézanne knew how to strip pictorial art of all the mold that had accumulated there through time. He showed that

imitation is only a means, that the only goal is to place lines and colors on a given surface, so as to please the eye, to talk to the spirit, to create in fact—by purely plastic means—a language, or rather to find once more the universal language. He is accused of uncouthness, of coldness; these are the outer trappings of his power, his apparent shortcomings! His thought is so clear in his mind! His desire to give utterance so compelling! If a tradition is born of our time—which I dare to hope it will be—it is from Cézanne that it will spring.

Others, clever cooks, will then come along to make his leftovers into more modern sauces; but it is he who will have given the marrow. It is not a question of a new kind of art, but of the resurrection of all arts that are *solid and pure and classical.*

"What Do You Think of Cézanne?"
Mercure de France, 1905

Paul Klee (1879–1940), Painter

I have been able to see eight of Cézanne's paintings at the Secession [of Vienna]. Here is, for me, the master *par excellence,* the very person to instruct me, much more so than Van Gogh.

Diary, 1908

Georges Rouault (1871–1958), French Expressionist Painter

Do not come near me, do not touch me: I carry within me all the beauty that the world does not know, or fails to recognize. Do not come near me, do not speak to me: Words and deeds are empty, I am silent, old, and powerless, all my efforts are aimed at Truth and Beauty. Essentially because of this, I have been forced to live far from men, I have had to meditate and suffer in order to accomplish what I had to do here.

"Making Cézanne Speak"
Mercure de France, 1910

Roger Fry (1866–1934), English Painter and Critic

I always admired Cézanne, but since I have had the opportunity to examine his pictures here [at the Grafton Galleries in London] at leisure, I feel that he is incomparably greater than I had supposed. His work has the baffling mysterious quality of the greatest originators in art. It has that supreme spontaneity as though he had almost made himself the passive, half-conscious instrument of some directing power. So little seems implied at first sight in his apparently accidental collocation of form and colour, so much reveals itself gradually to the fascinated gaze. And he was the great genius of the whole movement; he it was who discovered by some mysterious process the way out of the cul-de-sac into which the pursuit of naturalism *à outrance* had led art. As I understand his art, and I admit it is exceedingly subtle and difficult to analyse —what happened was that Cézanne, inheriting from the Impressionists the general notion of accepting the purely visual patchwork of appearance, concentrated his imagination so intensely upon certain oppositions of tone and colour that he became able to build up and, as it were, re-create form from within; and at the same time that he re-created form he re-created it clothed with colour, light and atmosphere all at once. It is this astonishing synthetic power that amazes me in his work. His composition at first sight looks accidental, as though he had sat down before any odd corner of nature and portrayed it; and yet the longer one looks the more satisfactory are the correspondences one discovers, the more certainly felt beneath its subtlety, is the architectural plan; the more absolute, in spite of their

astounding novelty, do we find the colour harmonies. In a picture like *L'Estaque* it is difficult to know whether one admires more the imaginative grasp which has rebuilt so clearly for the answering mind the splendid structure of the bay, or the intellectualized sensual power which has given to the shimmering atmosphere so definite a value. He sees the face of Nature as though it were cut in some incredibly precious crystalline substance, each of its facets different, yet each dependent on the rest. When Cézanne turns to the human form he becomes, being of a supremely classic temperament, not indeed a deeply psychological painter, but one who seizes individual character in its broad, static outlines. His portrait of his wife has, to my mind, the great monumental quality of early art, of Piero della Francesca or Mantegna. It has that self-contained inner life, that resistance and assurance that belong to a real image, not to a mere reflection of some more insistent reality. Of his still-life it is hardly necessary to speak, so widespread is the recognition of his supremacy in this. Since Chardin no one has treated the casual things of daily life with such reverent and penetrating imagination, or has found as he has, in the statement of their material qualities, a language that passes altogether beyond their actual associations with common use and wont.

"The Post-Impressionists—2"
Nation, 3 December 1910

Walter Sickert (1860–1942), Founder of the Camden Town Group

This article is taken from a lecture at the Grafton Galleries just before the close of the 1911 Cézanne exhibition.

Cézanne was fated, as his passion was immense, to be immensely neglected, immensely misunderstood, and now, I think, immensely overrated. Two causes, I suspect, have been at work in the reputation his work now enjoys. I mean two causes, after all acknowledgment made of a certain greatness in his talent. The moral weight of his single-hearted and unceasing effort, of his sublime love for his art, has made itself felt. In some mysterious way, indeed, this gigantic sincerity impresses, and holds even those who have not the slightest knowledge of what were his qualities, of what he was driving at, of what he achieved, or of where he failed.

"Post-Impressionists"
Fortnightly Review, January 1911

Albert Gleizes (1881–1953) and Jean Metzinger (1883–1956), French Cubist Painters

Cézanne is one of the greatest of those who changed the course of art history,

A 1916 interpretation of Cézanne's portrait of his wife by Spanish Cubist painter Juan Gris.

and it is inappropriate to compare him to Van Gogh or Gauguin. He brings Rembrandt to mind. Like the painter of *The Pilgrims of Emmaus*, ignoring everything marginal and incidental, he has plumbed the depths of reality with the eye of wisdom and if he himself has not arrived at those regions in which profound realism changes imperceptibly into luminous spirituality, at least he has left, for those who desire to attain it, a simple and wonderful method.

He has taught us to master the vitality of the universe. He has revealed how inanimate, raw objects inflict change on one another. From him we have learned that to alter the colouring of an object is to alter its structure. His work proves without doubt that painting is not—or not any longer—the art of imitating an object by lines and colours, but of giving plastic form to our nature.

To understand Cézanne is to foresee Cubism.

Du Cubisme, 1912

Robert Ross (1869–1918), Art Critic

This article in the London Times *is about a Post-impressionist exhibition at the Grafton Galleries that included approximately thirty of Cézanne's watercolors. The article was not signed but is presumed to have been written by Robert Ross.*

Like the Impressionists, Cézanne was constantly occupied with reality and tried to see it without any artistic prejudice; but he also incessantly tried to discover in it designs of abstract grandeur to which he would sacrifice all irrelevant fact, as the Impressionists sacrificed irrelevant fact to the facts which interested them. Both he and they maintained the freedom of the artist; but he made a different use of it. He was

not so much interested in any fact for its own sake as in a kind of music for the eye which he sought for in all facts and to which he subordinated them all. In this respect he was like many artists whom we call decorative; but he differed also from most of these in one important particular. The tendency of most decorative painting is to reduce everything to two dimensions. This is carried to its furthest point in pure pattern, as in a Persian carpet, where there is no representation at all, but only an abstract music for the eye.

But Cézanne's designs, however abstract, were always conceived in three dimensions; his music was a music of masses, not of lines or flat spaces. That is what makes his art original and at the same time difficult. For we are used to thinking of all the means by which mass is represented as means of pure illusion. We can see a harmony of pattern easily enough, because we are used to the sacrifices of fact necessary to produce it.

But we are not used either to harmonies of mass or to the sacrifices of fact necessary to produce them; and so pictures like Cézanne's *Rocks* may seem to us both meaningless and unbeautiful. They do not remind us either of rocks themselves or of a Persian carpet; they have neither illusion nor music for the eye. But Cézanne had learnt to compose in abstract masses as Cimabue [c. 1240–1302] could compose in lines and flat spaces, and he drew these masses without any design of producing an illusion of three dimensions, but only so as to reveal the new kind of music which he found in them. If, then, we are to understand his works and to see their beauty, we must not look for flat pattern in them nor must we look for the kind of abstract design that goes with flat

pattern. We must accustom ourselves to abstractions in three dimensions, to a new music of masses, which at first is very disconcerting to the eye.

"Cézanne and the Post-impressionists"
The Times, 8 January 1913

André Lhote (1885–1962), French Cubist Painter

Let us admit that there is nothing in all that has been attempted during these last twenty years that does not find its point of departure in Cézanne, and what is more, sometimes, its solution in advance. Those among us who had the most far-reaching creative spirit could only emphasize the most secret intentions of the master, and give more freedom to his actions, which were often restrained by excessive modesty.

La Peinture, le Coeur et l'Esprit, 1920

Maurice Denis (1870–1943), Leader of the Nabis Group (Post-impressionist Followers of Gauguin)

There is something paradoxical in Cézanne's fame; and it is no easier to explain than Cézanne himself. The Cézanne case irremediably divides into two camps—those who love painting and those who prefer its allied pleasures, literary or otherwise, to painting itself....

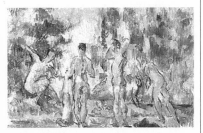

Bathers (1890–4), a painting that once belonged to Maurice Denis.

The mystery with which the master of Aix-en-Provence surrounded himself all his life has significantly contributed to the increasing obscurity of the commentaries that have themselves contributed to his fame. He is shy, independent, a recluse. Totally occupied with his art, perpetually anxious and usually dissatisfied with himself, he escaped public curiosity up to his last years. Even those who drew on the inspiration of his methods usually did not know him.

At a time when the sensibility of the artist was held almost unanimously to be the sole reason for the work of art, and when improvisation—this "spiritual giddiness originating in the exaltation of the senses"—tended to destroy the out-of-date academic conventions and the necessary methods, it so happened that Cézanne's art was able to keep the essential role of sensibility, while at the same time substituting reflection for empiricism.

For example, instead of mechanically noting phenomena, he was able to keep the feeling of the moment, though he overworked almost excessively, by planned and deliberate effort, at his studies from nature. He *composed* his still lifes, purposely altering lines and mass, placing draperies according to premeditated rhythms, avoiding the accidents of chance, seeking plastic beauty, but without losing the true *motif*.

This initial motif was to be captured in his sketches and watercolors; I mean by this the delicate symphony of lights and shades, placed side by side, which his eye discovered at once but which his reason then spontaneously supported with a logical composition or an architectural plan.

Théories, 1920

Kazimir Malevich (1878–1935), Russian Painter

Cézanne, one of the strongest of those who sense the element of painting in the artist, has the same reproaches thrown at him as the Impressionists. They say that Cézanne does not master the form of his drawings and cannot cope with sketches of the model. And in both Cézannism and Impressionism we meet the same question of lack of correspondence between the form and colour of a work, the form and colour of the model.

Farmyard at Auvers (c. 1879).

The paintings of Cézanne and the other artists of new art give us only signs of objects, which are greatly deformed in the interests of "art as such." The philistines among the critics regard this deformation as a fault, arising from an inability to draw and paint. In this way all the critics lose sight of the main point—the sensation arising from this or that attitude to the object and the changes in it.

In reality, things are completely the other way round: Cézanne is a great master because he was able to express painterly sensations in their pure form.… Cézannism is one of the greatest achievements in the history of painting on account of its pure definition of painterly *Weltanschauung* [a comprehensive vision of the world].

In the personality of Cézanne our history of painting reaches the apogee of its development.

There is one self-portrait by Cézanne which in a marvellous way brings out painterly sensation. Since the self-portrait does not correspond to the anatomical concept of reality, it cannot be called a self-portrait. The form of the model and the realization are different, leaving only the character, or signs of separate facial features.
We see the same divergence, to an ever greater degree, from the point of view of colour.

In the case in point the face is covered with such a colour mass that it could hardly correspond to reality and give the sensation of a body.

"An Attempt to Determine the Relation Between Form and Colour in Painting,"
Essays on Art, vol. 2
Edited by Troels Andersen, 1928–33
(Translated by Xenia Glowackacki-Prus and Arnold McMillin, 1968)

Pablo Picasso (1881–1973), the Most Influential Artist of the 20th Century

Cézanne was my one and only master! Of course I looked at his paintings.… I spent years studying them.… Cézanne was like the father of us all.

To Georges Brassaï, 1943
Quoted in Michel Hoog
Catalogue de l'Exposition Cézanne
Madrid, 1984

Pierre Bonnard (1867–1947), French Painter and Leading Member of the Nabis Group

Cézanne, in front of his subject, had a strong idea of what he wanted to do and only took from nature what had a bearing on his idea. It happened that he often remained like a lizard, warming himself in the sun, without even touching a brush. He could wait until things became once more just as they had entered his conception. He was the most powerfully armed painter facing nature, the strongest and the most sincere.

Observations collected by
Angèle Lamotte,
Quoted in *Verve*, 1947

Max Weber (1881–1961), Russian-born American Painter

Weber was a pioneer of Fauvisim, Cubism, and Expressionism, all of which trends in modern art were rooted in Cézanne's spatial and color experiments.

When I saw the first ten pictures by this master, the man who actually, I should say, brought to an end academism, I said to myself as I gazed and looked, after several visits, "This is the way to paint. This is art *and* nature, reconstructed," by what I should call today an engineer of the geometry of aesthetics. I came away bewildered. I even changed the use of my brushes. A certain thoughtful hesitance came into my work, and I constantly looked back upon the creative tenacity, this sculpturesque touch of pigment by this great man in finding form, and how he built up his color to construct the form.

Interview in 1959
Quoted in John Rewald
Cézanne and America, 1989

Cézanne photographed by Emile Bernard, 1904.

Truth in Painting

Cézanne's works cannot be explained by his life or his artistic influences. On the contrary, painting gave meaning to this man who worked unceasingly to "realize" his vision. French philosopher Maurice Merleau-Ponty (1908–61) retraces the steps of the man who wished to unite art and nature.

Cézanne's Doubt

He needed a hundred working sessions for a still life, a hundred and fifty sittings for a portrait. What we call his work was for him only an experiment and an approach to his painting. He wrote in September 1906, aged sixty-seven, one month before his death: "I am in such a state of mental confusion, in such great agitation that I have feared for my reason for a time.... Now I seem to be better and am thinking more precisely about the direction of my studies. Shall I ever arrive at the goal which has been so much sought and so long pursued? I study from nature always and it seems to me that I proceed very slowly." Painting was his world and his way of life. He worked alone, with no pupils, with no admiration from his family, no encouragement from the juries. He

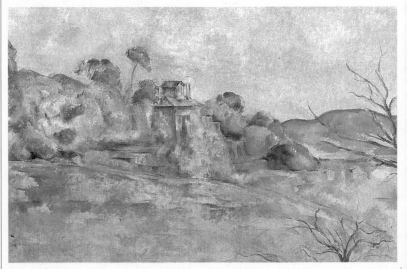

Landscape of the Midi (c. 1885). "I must search for the expression of what I feel and organize my feelings into my own personal aesthetic."

even painted the afternoon of his mother's death. In 1870 he painted at L'Estaque while policemen were searching for him as a defaulter [avoiding conscription for the Franco-Prussian War, which had broken out that summer].

And yet he got to the point of calling this vocation in question. As he grew old, he wondered whether the innovation of his painting did not come from defective eyesight, if all his life had not been founded on a chance formation of his body.

The Paradox

His painting is a form of paradox: searching for reality without giving up sensation, without taking any other guide than the immediate impression of nature, without outlining contours, without framing color in drawing, without composing perspective or the picture. That is what Emile Bernard calls Cézanne's suicide: He aims at reality and forbids himself the means of attaining it. There lies the reason for his difficulties and also for the distortions that are found, especially between 1870 and 1890. Plates or cups placed in profile on a table should be ellipses, but the two apexes of the ellipse grow enlarged and dilated. The work table, in the portrait of Gustave Geffroy [see p. 104b], spreads out in the lower part of the picture against all the laws of perspective.

In abandoning drawing, Cézanne was said to be giving himself up to the chaos of sensations. Now sensations would upset objects and constantly suggest illusions, as they sometimes do—for example the illusion of objects moving when we shake our heads—if judgment did not constantly correct appearances. Cézanne, says Bernard, engulfed "painting in ignorance and his mind in darkness."

To Unite Art and Nature, the Senses and the Intellect

In his conversations with Emile Bernard, it is obvious that Cézanne is always seeking to escape all the ready-made alternatives being suggested to him— that of the senses or the intellect, of the painter who sees and the painter who thinks, of nature and composition, of primitivism and tradition. "You have to have a point of view," he said, but "by a point of view I mean a logical vision, that's to say, nothing absurd." "Is it a question of our nature?" asks Bernard. Cézanne replies, "It is a question of both."

"Aren't nature and art different?"— "I would like to unite them. Art is a personal apprehension. I place this apprehension in sensation and I ask the intellect to organize it into a work of art." But even these formulae make too much room for ordinary ideas of "sensibility" or "sensation" and "intellect"; that is why Cézanne could not convince and why he preferred to paint. Instead of applying dichotomies to his work that belong more to scholastic traditions than to the founders—philosophers or painters—of these traditions, it would be better to be receptive to the real meaning of his painting, which is to call them into question. Cézanne did not believe he had to choose between sensation and thought, as though between chaos and order. He did not wish to separate static things which appear beneath our gaze from their fleeting manner of appearance; he wanted to paint matter in the act of taking on form, order being born through spontaneous organization. He did not make a division between "the senses" and "the intellect," but between the spontaneous order of things

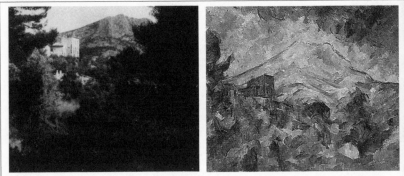

Mont Sainte-Victoire and Château Noir. Left: A photograph of c. 1935. Right: A painting of 1904–6. "His pictures give the impression of nature at its source, whereas photographs of the same landscapes suggest the works of humanity, its convenience, its looming presence."

perceived and the human order of ideas and knowledge. We perceive things, we agree about them, they are deep-rooted in us and it is on the basis of this "nature" that we erect knowledge. It is this primeval world that Cézanne wanted to paint, and that is why his pictures give the impression of nature at its source, whereas photographs of the same landscapes suggest the works of humanity, its convenience, its looming presence. Cézanne never wished to "paint like a brute beast," but to put the intellect, ideas, knowledge, perspective, and tradition in touch once more with the natural world: to confront, as he said, knowledge "which issued from it" with nature itself.

Cézanne's experiments in perspective, through their faithfulness to phenomena, laid bare what recent psychology was to define. Our actual experience of perspective, that of our perception, is not geometric or photographic perspective at all: in our perception, nearer objects appear smaller, farther-off objects larger than they do in a photograph; just

as can be seen in a cinema when a train gets nearer and nearer and grows larger much more quickly than a real train in the same circumstances....

Cézanne's genius is to arrange the whole picture so that the distortion of perspective ceases to be visible in itself when one looks at it as a whole, and only gives the impression, as in normal vision, of a new order being born, of an object in the act of appearing, in the act of coming together in front of our eyes. In the same way the contour around objects, thought of as a line which surrounds them, does not belong to the visible world but to geometry. If the contour of an apple is marked with a line it is made into a thing, whereas really this contour is the ideal limit to which the sides of the apple escape in depth. If you don't draw any contour, that would mean taking an object's identity away. If you draw one contour only, that would mean sacrificing depth, that is to say the dimension which gives us the thing, not as it were laid out before us, but full of reservations, and like an inexhaustible reality. That is

why Cézanne will follow the swelling of an object with modulated colors, and will mark *several* contours with blue lines. The eye, thrown back from one to the other, apprehends a contour nascent between them all, just as it does in the perception. There is nothing less arbitrary than those famous distortions which Cézanne was anyway to abandon in his last period from 1890, when he was no longer to fill his canvas with colors and was to give up his constant production of still-lifes.

"When the Color Is Rich, the Form Is at Its Height"

Drawing ought to grow out of color, if one wishes the world to be rendered

Self-portrait (c. 1880).

in all its density, for it is a mass without breaks, an organism made of colors, across which the flight of perspective, contours, straight lines and curving lines settle down like lines of force and the framework of space is formed and vibrates. "Drawing and color are not separate and distinct, as everything in nature has color. While one paints, one draws; the more the color harmonizes, the more precise becomes the drawing. When the color is rich, the form is at its height." Cézanne does not seek to *suggest* tactile sensations, which would give form and depth, by color. In primeval perception, distinctions between touch and sight are unknown. It is the knowledge of the human body which teaches us in the end to distinguish between our senses. The actual experience is not found or made from sense data themselves, but directly presents itself as the center from which sense data radiate. We *see* the depth, the velvet softness and the hardness of objects. Cézanne even said that the arrangement of colors must carry within it this indivisible whole; otherwise his painting would be an allusion to things and would not render them in their imperious unity, in their presence and in that unsurpassed completeness which is for us all the definition of reality. That is why each brushstroke made had to satisfy infinite conditions, that is why Cézanne used to meditate for perhaps an hour before placing it; it had to "contain the air, the light, the object, the plan, the character, the drawing, the style," as Emile Bernard said. The expression of that which *exists* is an infinite task.

Maurice Merleau-Ponty
Sens et Non Sens
1948

Cézanne's Apples

All his life Cézanne painted apples, and various meanings have been given for their repeated presence in the artist's pictures: They are a souvenir of his friendship with Zola, objects gathered at random from the artist's studio, or a simple motif that allowed the painter to concentrate on technique and form. Here modern art historian Meyer Schapiro suggests a psychoanalytic interpretation.

Cézanne worked on The Judgment of Paris *between 1883 and 1885. In it an amorous male figure (Paris) offers an armful of apples to a nude female. Basing his essay on this painting, doubtless inspired by Cézanne's memories of Latin poetry, Meyer Schapiro reflects on apples and eroticism in the painter's work.*

Apples of Friendship

Cézanne could more readily respond to this classic pastoral theme, since in his own youth a gift of apples had indeed been a sign of love. In his later years he recalled in conversation that an offering of apples had sealed his great friendship with Zola. At school in Aix Cézanne had shown his sympathy for the younger boy who had been ostracized by his fellow-students. Himself impulsive and refractory, Cézanne took a thrashing from the others for defying them and talking to Zola. "The next day, he brought me a big basket of apples. 'Ah! Cézanne's apples,' he said with a playful wink, 'they go far back.'"...

Apples of Love

The central place given to the apples in a theme of love invites a question about the emotional ground of his frequent painting of apples. Does not the association here of fruit and nudity permit us to interpret Cézanne's habitual choice of still-life—which means, of course, the apples—as a displaced erotic interest?

One can entertain more readily the idea of links between the painting of apples and sexual fantasy since in Western folklore, poetry, myth, language and religion, the apple has a familiar erotic sense....

Apples are associated—either consciously or unconsciously—with love. Above and detail opposite: *Still Life with a Plaster Cupid* (c. 1895).

Fructus—the word for fruit in Latin—retained from its source the verb *fruor*, the original meaning of satisfaction, enjoyment, delight. Through its attractive body, beautiful in color, texture and form, by its appeal to all the senses and promise of physical pleasure, the fruit is the natural analogue of ripe human beauty....

"I Want to Conquer Paris With an Apple"

In paintings of the apples he was able to express through their more varied colors and groupings a wider range of moods, from the gravely contemplative to the sensual and ecstatic. In this carefully arranged society of perfectly submissive things the painter could project typical relations of human beings as well as qualities of the larger visible world—solitude, contact, accord, conflict, serenity, abundance and luxury—and even states of elation and enjoyment. The habit of working expressively in this way with still-life objects reflects a root attitude that had become fixed at an early point in his career, before the apples were a major theme. But from the remark about Paris and the apple we divine the seriousness of Cézanne's special concentration on the fruit that was to serve him as an instrument for the highest achievement. He not only proclaims that his homely rejected self will triumph through a humble object. By connecting his favored theme with the golden apple of myth he gave it a grander sense and alluded also to that dream of sexual fulfillment which Freud and others of his time too readily supposed was a general goal of the artist's sublimating effort.

Meyer Schapiro,
"The Apples of Cézanne:
An Essay on the Meaning
of Still-life,"
*Modern Art: 19th and 20th Centuries,
Selected Papers*, 1978

Mont Sainte-Victoire

Heavy with symbolism, this mountain fascinated all the inhabitants of Aix, especially Cézanne. The painter appropriated Mont Sainte-Victoire for his own, and today it has acquired a new dimension for everyone: the dimension given by Cézanne.

The Late Mont Sainte-Victoires

In some of [his last views of the Mont Sainte-Victoire], the canvas is densely coated with overlaid touches of colour through which the forms of the landscape appear barely discernible, a painful reminder of the aged artist's creative torments—and tenacity. Others —especially in watercolour—possess a delicacy and lyricism which appear infinitely consoling. Employing myriad flame-like strokes of colour Cézanne creates in these a kind of mystic notation —or visual music—to evoke the celestial harmonies of nature. In several oils and watercolours, the artist even inverts the contour of the mountain in a sequence of coloured touches which converge upon the bottom centre of the composition. These afford moving evidence of the indissoluble order which he believed permeated all facets of creation.

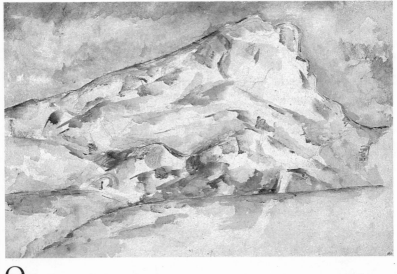

One of the last in the Mont Sainte-Victoire series (1900–2).

Most visionary of all, however, are those late views of the mountain floating weightlessly over the plain, like some spiritual intercessor between man and the divine. In certain of these the hues of the land are discharged into the sky, with Cézanne wringing from them all earthly impurity and permitting them simply to ascend, ecstatic affirmations of both human aspiration and universal harmony. Works such as these communicate a mystical belief in the transcendent beauty of creation which justifies Rilke's assertion that Cézanne set himself before a landscape "drawing religion from it."

Richard Verdi
Cézanne, 1992

Seeing the Mountain As It Is

Mont Sainte-Victoire is not the highest point of Provence, but it is, they say, the most precipitous. It does not consist of a single summit but is a long chain whose crest follows an almost straight line at a constant height of about a thousand meters. It does not look like an abrupt peak except when seen from below in the Aix basin, which is about half a day's walk to the west: What appears from there to be the real summit is only the beginning of the crest that extends another half day's walk to the east.

This chain which rises in a gentle slope to the north, and falls away almost vertically from the plateau to the south, is a powerful calcareous fold whose ridge is the upper longitudinal axis. Seen from the west, these three points take on a dramatic appearance, for they represent in many ways a cross-section of the whole massif and of its various folds, to such an extent that anyone who knew nothing about this mountain would be able to guess its origin, even without wanting to, and would see there something exceptional....

What is so astonishing and so strange about Mont Sainte-Victoire is especially the brightness and dolomitic glare of the limestone, "a rock of the highest quality," as a brochure for mountaineers reads. There is no road. The whole mountain and even the very gentle north slope are devoid of any road suitable for motor vehicles and any inhabited house (though there is still an abandoned 17th-century priory on the crest). The steep flank is accessible only to mountaineers; but all the other sides can be climbed without difficulty and one can continue for a long way still on the crest. Even from the nearest village it is a whole day's undertaking.

That July day when I was going eastward along the Paul Cézanne road, I had barely left Aix when I began to toy with the idea of giving travel advice to a crowd of unknown people (and yet I was only one of many who had followed this route from the beginning of the century). It had long been a game to see the mountain as it really was. Perhaps this cherished motif of a painter had already become something of an *idée fixe*. It was only on the day when the idea with which I was toying suddenly took over my imagination that all at once the resolution was made (accompanied at once by a feeling of pleasure): Yes, I was going to see Mont Sainte-Victoire from close at hand! And thus it was that I set out, not so much on the track of the exact features that Cézanne had seen, for I knew, after all, that most of them had been altered subsequently, but rather I followed my feelings: It was the mountain that was drawing me as nothing else in my life had drawn me.

Peter Handke
Die Lehre der Sainte-Victoire
(The Lesson of Sainte-Victoire)
1980

Further Reading

Badt, Kurt, *The Art of Cézanne,* trans. Sheila Ann Ogilvie, Hacker Books, New York, 1985

Barnes, Albert C., and Violette de Mazia, *The Art of Cézanne,* Barnes Foundation Press, Merion, Pennsylvania, 1939

Barskaya, Anna, *Paul Cézanne: Paintings from the Museums of the Soviet Union,* Aurora, Leningrad, 1985

Bernard, Emile, *Souvenirs sur Paul Cézanne,* A la Rénovation Esthetique, Paris, 1921

Bullen, J. B., ed., *Post-Impressionists in England: The Critical Reception,* Routledge Chapman and Hall, New York, 1988

Chappuis, Adrien, *The Drawings of Paul Cézanne: A Catalogue Raisonné,* 2 vols., Thames and Hudson, London and New York, 1973

Denis, Maurice, *Théories,* L. Rouart and J. Watelin, Paris, 1920

Denvir, Bernard, ed., *The Impressionists at First Hand,* Thames and Hudson, London and New York, 1987

Fry, Roger, *Cézanne: A Study of His Development,* University of Chicago Press, 1989

Handke, Peter, *Die Lehre der Sainte-Victoire,* Suhrkamp, Frankfurt, 1980

Joachim Gasquet's Cézanne: A Memoir with Conversations, trans. Christopher Pemberton, Thames and Hudson, London and New York, 1991

Kendall, Richard, ed., *Cézanne by Himself: Drawings, Paintings, Writings,* Bullfinch Press, Boston, 1988

Lewis, Mary Tompkins, *Cézanne's Early Imagery,* University of California Press, Berkeley, California, 1989

Loran, Erle, *Cézanne's Composition,* University of California Press, Berkeley, California, 1943

Mack, Gerstle, *Paul Cézanne,* Paragon House, New York, 1990

Malevich, Kazimir, *Essays on Art,* 2 vols., trans. Xenia Glowackacki-Prus and Arnold McMillin, G. Wittenboin Publishers, New York, 1971

McLeave, Hugh, *A Man and His Mountain: The Life of Cézanne,* Macmillan, New York, 1977

Orienti, Sandra, *The Complete Paintings of Cézanne,* Penguin Books, Harmondsworth, England, 1985

Rewald, John, *Paul Cézanne: The Watercolors,* Harry N. Abrams, New York, 1983

————, *Cézanne and America: Dealers, Collectors, Artists and Critics 1891–1921,* Princeton University Press, Princeton, New Jersey, 1989

————, *Cézanne, The Steins and Their Circle,* Thames and Hudson, London and New York, 1986

————, *Cézanne: A Biography,* Harry N. Abrams, New York, 1986

————, ed., *Paul Cézanne Letters,* trans. Marguerite Kay, 5th ed., Hacker Books, New York, 1985

Rilke, Rainier Maria, *Letters on Cézanne,* ed. Clara Rilke, trans. Joel Agee, Fromm International Publishers, New York, 1984

Schapiro, Meyer, *Paul Cézanne,* Harry N. Abrams, New York, 1988

————, *Modern Art: 19th and 20th Centuries,* Braziller, New York, 1978

Shiff, Richard, *Cézanne and the End of Impressionism: A Study of the Theory, Technique and Critical Evaluation of Modern Art,* University of Chicago Press, 1984

Venturi, Lionello, *Cézanne,* Skira, Geneva, 1978

Verdi, Richard, *Cézanne,* Thames and Hudson, London and New York, 1992

————, *Cézanne and Poussin: The Classical Vision of Landscape,* Lund Humphries, London, 1990

Vollard, Ambroise, *Cézanne,* Dover Press, New York, 1984

Wechsler, Judith, *Cézanne in Perspective,* Prentice-Hall, Englewood Cliffs, New Jersey, 1975

Zola, Emile, *L'Oeuvre,* trans. as *The Masterpiece* by Thomas Walton, rev. ed., Oxford University Press, Oxford, England, and New York, 1993

EXHIBITION CATALOGUES

Cézanne dans les Musées Nationaux, Musée de l'Orangerie, Paris, 1974

Cézanne's Paintings, Edinburgh, Royal Scottish Academy, and London, The Tate Gallery, 1954

Gowing, Sir Lawrence, *Cézanne: The Early Years 1859–1872,* Royal Academy of Arts, London, 1988

Krumrine, Mary Louise, *Paul Cézanne: The Bathers,* Kunstmuseum, Basel, 1989

Paul Cézanne, Museo Español de Arte Contemporaneo, Madrid, 1984

Rubin, William, ed., *Cézanne: The Late Work,* The Museum of Modern Art, New York, 1977

List of Illustrations

Index

Acknowledgments

The author particularly wishes to thank Madame Sylvie Maignan for her help and advice. The publishers thank Editions Flammarion, Editions Macula, Editions Nagel, Editions de la Réunion des Musées Nationaux, and the Musée Granet at Aix-en-Provence.

Photograph Credits

Agraci, Paris 97a. Albright-Knox Art Gallery, Buffalo 50–1b. All rights reserved 33al, 36–7, 100–1a, 100–1b, 130, 162l. Artephot 149. Artephot/Babey 36, 122bl, 122br. Artephot/Bridgeman Art Library 34, 45l, 84–5, 90br, 91b, 94, 98a, 98c, 98b, 111al, 120–1. Artephot/Cercle d'Art 86a. Artephot/Faillet 22bl, 97b. Artephot/Held 41, 60, 90bc, 91bc, 105, 106, 125a, 125b, front cover. Artephot/Hinz Colorphoto 90a, 91a. Artephot/J. Martin 46–7a. Artephot/Nimatallah 65a, 86b, 136–7. Artephot/Trela 21b, 45r, 141. The Art Institute of Chicago 52, 111ar, 163. Baltimore Museum of Art back cover. Barnes Foundation, Merion, Pennsylvania 99a, 117a. Bibliothèque Nationale, Paris 18, 24r, 46–7b, 131, 135, 159. Bridgestone Museum of Art, Tokyo 162r. Brouchian F., Aix-en-Provence 50a. Bulloz, Paris 19l, 19r, 150. Columbus Museum of Art, Ohio 50b. Courtauld Institute Galleries, London 100a, 164, 165. Dagli Orti, Paris 26–7. Edimédia, Paris 56, 68–9, 89ar, 102–3. The Fitzwilliam Museum, Cambridge, England 67. Fogg Art Museum, Cambridge, Massachusetts 42, 43. Galerie Bernheim Jeune, Paris 129. Galerie Louise Leiris, Paris 155. Galerie Schmidt, Paris 160. The J. Paul Getty Museum, Malibu, California 23. Giraudon, Paris 90bl, 91ca, 91r. Harlingue-Viollet, Paris 21a. The Harvard University Art Museums, Cambridge, Massachusetts 74–5, 77b. Heald David 46l. Henry Ely, Aix-en-Provence 86–7, 96–7. Josse, Paris 79. Kunstmuseum, Basel 55a, 60–1b, 76–7, 77a, 78–9, 89cr, 92–3, 117b. Lauros/Giraudon 104a, 118–9, 124, 138. Memorial Art Gallery, Rochester, New York 55b. The Metropolitan Museum of Art, New York 14r, 88, 99b. Musée Calvet, Avignon 21c. Museum Boymans-van Beuningen, Rotterdam 44c, 65b. Museum of Art, Philadelphia 66r, 125c. The Museum of Fine Arts, Boston, Massachusetts 40, 128. The Museum of Modern Art, New York 108–9, 111b. National Gallery of Art, Washington, D.C. 28, 28–9, 122a. The National Museums and Galleries on Merseyside, Walker Art Gallery, Liverpool 25. Nationalmuseum, Stockholm 103. The National Museum of Wales, Cardiff 16. Réunion des Musées Nationaux, Paris 1, 2–9, 11, 12, 22a, 24, 27br, 28–9a, 30, 31, 32r, 33ar, 44l, 45c, 48, 48–9a, 48–9b, 49b, 52–3, 53, 56–7, 58–9, 61l, 61r, 62, 63, 64, 66l, 70, 71, 72–3, 80–1, 82–3, 83a, 83bl, 83br, 89c, 89b, 92a, 93, 95, 98, 100b, 102l, 102r, 104b, 110, 139, 146, 151, 157, 158, 166. The Saint Louis Art Museum, Saint Louis 14l. Scala, Florence 38, 39, 112–3, 114–5, 126–7. Sipa Icono 106–7. Sirot-Angel, Paris 78, 116–7, 133, 135, 150. Terlay B., Aix-en-Provence 15l, 15r, 20, 144. Thyssen-Bornemisza Collection, Lugano 123

Text Credits

Grateful acknowledgment is made for use of material from the following works: John Rewald, *Cézanne: A Biography*, 1986, copyright © 1986 Harry N. Abrams, B. V., The Netherlands; reprinted by permission of Harry N. Abrams, Inc., New York (pp. 35, 140); *Cézanne by Himself*, edited by Richard Kendall, 1988. Reprinted by permission of Little, Brown and Company (UK) Ltd, London (pp. 136–7); John Rewald, *Cézanne: The Late Work*, edited by William Rubin, published by The Museum of Modern Art, New York, 1977, copyright © 1977 by The Museum of Modern Art, New York, painting entries in catalogue copyright © 1977 by John Rewald, watercolor entries copyright © 1977 by Adrien Chappuis and John Rewald. Reprinted by permission of The Museum of Modern Art and John Rewald (pp. 109, 119); Kazimir Malevich, "An Attempt to Determine the Relation between Form and Colour in Painting," *Essays on Art*, vol. 2, edited by Troels Andersen, trans. by Xenia Glowackacki-Prus and Arnold McMillin, 1968, copyright © 1968 Borgens Forlag A/S. Reprinted by permission of Borgens Forlag A/S, Valby, Denmark (p. 158); Meyer Schapiro, "The Apples of Cézanne: An Essay on the Meaning of Still-life," *Modern Art: 19th and 20th Centuries*, 1978, copyright © Meyer Schapiro 1968. Reprinted by permission of Chatto and Windus Ltd, London, the Estate of Meyer Schapiro, and George Braziller Inc., New York (pp. 164–5)

Michel Hoog is the chief curator at the Musée de
l'Orangerie, Paris, and has organized several exhibitions,
including "Robert Delaunay" (at the Musée de l'Orangerie,
1976); "Realism and Poetry in Russian Painting of the
19th Century" (at the Grand Palais in Paris, the National
Gallery of Canada at Ottawa, and the Californian Palace
of the Legion of Honor at San Francisco, 1982–3);
and "Le Douanier Rousseau" (at the Grand Palais in Paris
and the Museum of Modern Art in New York, 1984).
A professor at the Ecole du Louvre in Paris since 1971,
Hoog has written numerous books about art, most of
which have been translated into several languages.

Translated from the French by Rosemary Stonehewer

Project Manager: Sharon AvRutick
Typographic Designer: Elissa Ichiyasu
Editor: Jennifer Stockman
Design Assistant: Miko McGinty

Library of Congress Catalog Card Number: 93–72815

ISBN 0–8109–2879–5

Copyright © 1989 Gallimard/Réunion des Musées Nationaux

English translation copyright © 1994 Harry N. Abrams, Inc., New York,
and Thames and Hudson Ltd., London

Published in 1994 by Harry N. Abrams, Incorporated, New York
A Times Mirror Company

All rights reserved. No part of the contents of this book may be reproduced
without the written permission of the publisher

Printed and bound in Italy by Editoriale Libraria, Trieste